THE HISTORY AND TECHNIQUES OF THE GREAT MASTERS

TITIAN

THE HISTORY AND TECHNIQUES
OF THE GREAT MASTERS

TITIAN

Iain Dickson Gill

CHARTWELL
BOOKS, INC.

A QUARTO BOOK

Published by Chartwell Books
A Division of Book Sales, Inc.
110 Enterprise Avenue
Secaucus, New Jersey 07094

ISBN 1-55521-495-9

This book was designed and produced by
Quarto Publishing plc
The Old Brewery, 6 Blundell Street
London N7 9BH

Project Editor Hazel Harrison
Designer Carol Perks
Picture Researcher Liz Somerville

Art Director Moira Clinch
Editorial Director Carolyn King

Typeset by Aptimage Limited
22 Clinton Place, Seaford, East Sussex BN25 1NP
Manufactured in Hong Kong by Regent
Publishing Services Limited
Printed in Hong Kong by Leefung-Asco
Printers Ltd

CONTENTS

INTRODUCTION

"Titian walks alone as the equal of Nature," wrote his friend and biographer Ludovico Dolce in 1557, "so that each of his figures is alive, moves, its flesh quivering. He has displayed in his works no empty grace, but colors appropriate to their task." For Titian this task was that "the painter... must always aim at what is suited to each subject, and represent each person with his true character and emotions, which practice will gratify the beholders amazingly."

TITIAN
Self-portrait
c 1565-70, Prado, Madrid

Titian's greatness lies in his ability to use color to catch nature's shimmering surface, while also penetrating this surface to illuminate the psychological aspects of human nature. His name is synonymous with color, light and mood, and although similar concerns had occupied earlier Venetian painters, Titian took them a step further, translating them into a visual metaphor for the very stuff of nature. In Titian's paintings, brushstrokes are used as the outer expression of an inner response, describing physical and emotional nuances in a way that had never been done before, and was to mold the vision of his contemporaries and later European painters until this day.

Oil paint: the "new" medium

The innovation that helped the Venetian painters to catch the characteristic properties of light was oil paint, not a totally new medium, but one which was beginning to be exploited in new ways. Oils had been perfected by early 15th-century Flemish painters, such as Jan Van Eyck (who is often credited as their inventor) and were introduced to Venice by artists such as Antonello da Messina. Unlike the water-based medium, tempera, they were ideally suited to reflect and soak up light, dissolving forms and contours.

Venice, a dominant port surrounded by sea, was well placed to absorb ideas both from the East on one side and the Italian peninsula on the other. Previously, the influence of Byzantine art from the East had been para-

mount, with its emphasis on color and flat, stylized pattern as a means of spiritual expression, but now the northern Gothic painting showed the Venetians a different approach, in which oil paint was used to capture the subtleties and intricate details of the visual world. This new naturalism was taken further with the rise of Humanism, particularly in Florence, when artists and architects combined in a return to Classical ideals of balance and harmony, treating human subjects with an increased understanding of their individual emotions and characteristics.

By the middle of the 16th century, Venice was the only one of the Italian states to maintain its independence, and consequently was far less disturbed by the political and economic troubles that were to unsettle Rome, Florence and Italy in general. She was still a major center for commerce, and artists were in the fortunate position of being able to take first pick from a wide range of high-quality pigments before they were sent to other parts of the country. In Venetian painting these superior pigments were combined with a greater flexibility of technique to give warmth and humanity to Renaissance ideals, celebrating the sensory pleasures of life with light and color.

Tempera, which had been used both for church frescoes and paintings on wooden panels, imposed severe limitations on the artist, and in Venice both pigment and surface were adversely affected by the city's humidity. Oil was far more stable as well as more convenient, as it enabled artists to work in their studios, for prolonged periods if necessary, on canvases which could then be transported easily to their destinations. They could also work from live models under controlled lighting conditions. In addition to the technical innovations, there were changes in the subject matter available to artists. Religious paintings were still needed, but more and more learned and scholarly patrons were demanding secular works with themes drawn from

antiquity and mythology, subjects suitable for more intimate, private and domestic settings.

The Venetian legacy

This legacy of innovations in both materials and subject matter was the one inherited by Tiziano Vecellio, born between 1477 and 1490 in Pieve di Cadore, high in the Italian Dolomites. His grandfather, Count Vecellio, had been an important official in the garrison at Pieve, and his father Gregorio was captain of the same garrison, later becoming supervisor of the mines at Cadore. While still a child, Titian was sent to the house of a relative in Venice, and then became an apprentice to the mosaicist Zuccato, who quickly recognized his talent, and in about 1500 sent him to study with Gentile Bellini. As an apprentice he would have begun by cleaning brushes and palettes, then learned to grind colors and prepare surfaces before eventually being allowed to paint small areas for his master.

Gentile Bellini's linear and rather anecdotal approach evidently did not appeal to the impatient young man, and it seems his master did not think highly of him either — he is recorded as saying that his pupil painted too rapidly and would never amount to anything. Titian left to study under Gentile's less conservative brother, Giovanni. According to the contemporary art historian Vasari, both Giorgione and Sebastiano del Piombo were also in the studio at this time, when Giovanni must have been about seventy — his dates are uncertain. He must have had a powerful effect on the three young painters, for as Dürer said in 1506, "though he is old he is still the best in painting."

To appreciate Titian's paintings to the full it is helpful to look first at the work of his master, the artist who influenced him the most in his early years. At the end of the 15th century, Giovanni Bellini was the leading Venetian painter, and in his work the glowing impact of the earlier mosaics and gilded panels was translated into oil. His paintings are based on visual observation, but light and color are reinterpreted in a way that expresses the Divinity though the subtle illumination of diffused light. Unlike the Florentines, he saw line as artificial, and he rejected linear perspective, which creates depth by presenting things in an orderly progression. Instead he painted color and space as we actually perceive them. In such paintings as the *Sacred Allegory,* he built up a rich surface pattern (not unlike the earlier mosaics) which, rather than separating the various objects, seems to fuse them together through related colors, producing an almost palpable sensation of air and atmosphere.

With Bellini, landscape became a major concern of Venetian art, and this can be seen in the work of both Titian and Giorgione. Titian's early religious paintings also reflect the influence of Bellini, whose characteristic half-length Madonnas, often set against a curtain backdrop with a glimpse of landscape to the side, find an echo in Titian's *Gipsy Madonna.*

Painted poetry

In the landscape to Titian's painting, however, the lone armored figure sitting beneath a tree adds a sense of mystery, implying a narrative, but revealing nothing but an enigmatic and indefinable mood. This type of painterly analogy to poetry seems to have been created by

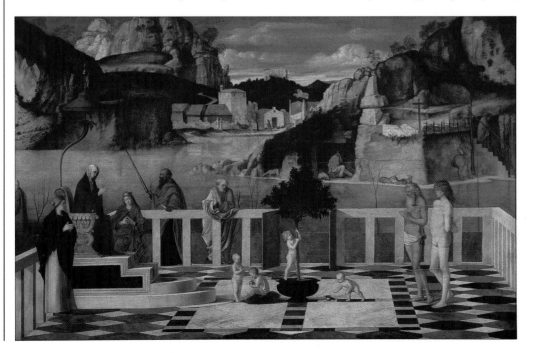

GIOVANNI BELLINI
Sacred Allegory
c 1490, Uffizi, Florence

This work, once thought to be by Giorgione, creates a dream-like world in which the allegorical references of the title remain elusive. On a cushion in the center sits the Christ-child, holding an apple that may symbolize original sin. Beneath a vine (referring to the blood of Christ) sits the Virgin Mary, blessing or in judgment, between two women who may possibly stand for Mercy and Justice. The landscape setting is hauntingly real, creating a hallucinatory stillness that seems to make the hidden ritual all the more tantalizing.

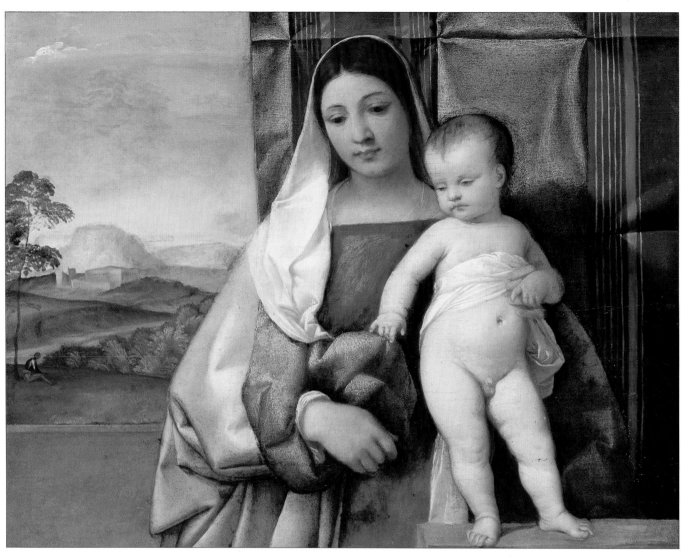

TITIAN
The Gipsy Madonna
c 1510, Kunsthistorisches
Museum, Vienna

The Madonna set against a
curtain derives from Bellini's
half-length Madonnas, but in
Titian's painting there is a
fullness to the forms and their
mass is complemented by the

spatial delicacy of a
"Giorgionesque" landscape.
Rich color harmonies are
heightened by the green
balancing the touches of red
that model the Madonna's
face. The pyramidal
composition, with the face at
its peak, is typical of the High
Renaissance.

Giorgione, who was another powerful influence on
Titian in his early years. In works such as *The Tempest*
Giorgione exploited the new secular subject matter in a
way that created a poetic response to natural phenom-
ena, working up a tonal structure from dark to light and
using a *sfumato* technique (soft, edgeless gradations of
tone and colour) to give his forms a brooding, atmos-

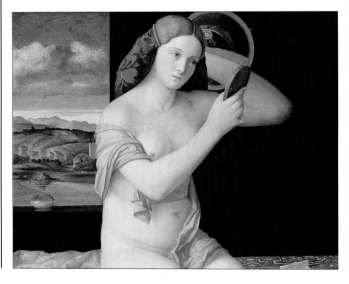

GIOVANNI BELLINI
Young woman with a Mirror
1515, Kunsthistorisches
Museum, Vienna

Bellini's characteristic
composition of a Virgin before
a curtain backdrop, with a
landscape behind, is here
given a secular interpretation

as a mortal Venus is molded
by soft, filtering light. Her
fullness is perfectly balanced
against exquisite detailing.
Titian was to draw upon both
the sacred and the earthly
variants of Bellini's works in
such contrasting works as the
Gipsy Madonna (below) and
the *Danaë* (see page 49).

8

pheric presence. Here air both unites and confuses boundaries of form and meaning, and one feels the presence of the artist hovering over the surface of the canvas. The oil technique, emphasizing the marks of the brush, made the artist a less anonymous figure.

The Venetians tended to favor a fairly coarse canvas that encouraged an inventive use of paint, which could be dragged across the grain, producing texture and broken touches of color. This emphasized their enjoyment in manipulating pigments in a sensuous and painterly manner. This relish for the tactile quality of paint comes across very strongly in Titian's paintings. He was the first artist to really exploit the brushstroke as an expressive force in its own right, as important, in its way, as the subject itself. His emphasis on brushwork, stressing coloring as a means of describing form, in contrast with the Florentine preference for line, is made much of by Vasari in his anecdote about a visit in 1546 by Michelangelo to Titian's studio in Rome. Michelangelo had remarked on leaving that he liked the coloring, but that "it was a pity that in Venice one was not taught from the beginning to draw well."

The state painter

In 1510, possibly to avoid the plague that caused Giorgione's premature death, Titian went to Padua, where he painted a series of frescoes, and his work matured in both conception and technical ability. On returning to Venice, with a confidence that might be seen as bordering on arrogance, he offered in 1513 to paint a battle

GIORGIONE and/or TITIAN
Concert Champêtre
c 1510, Louvre, Paris

Titian and Giorgione had worked together in the studio of the elderly master Giovanni Bellini, and for many years the attribution of this work has been the subject of much controversy. Believed at first to be by Giorgione, it was then thought to have been completed by the young Titian after his friend's premature death. In recent years, however, it has been increasingly attributed to Titian himself. The confusion underlines two artists' common concerns and the debt owed to Giorgione by Titian. As the figures harmonize to make music together, their notes linger on the warm air, as ephemeral as the sound of the water being poured into the well.

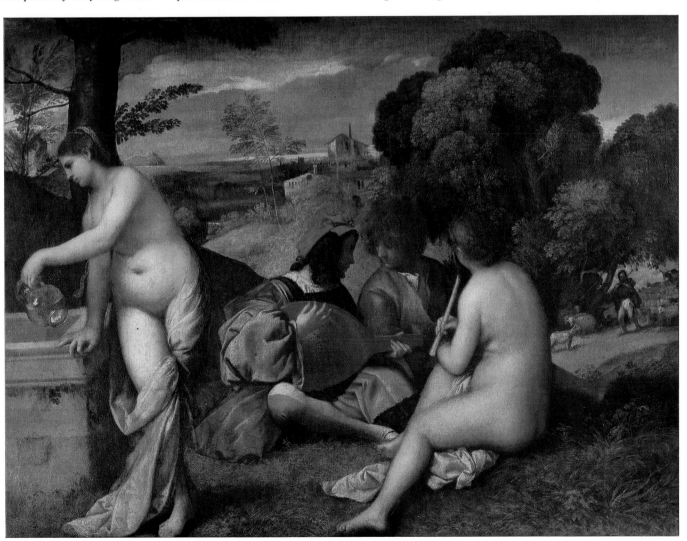

scene to replace a badly deteriorated 14th-century fresco. In return for this he asked to be granted the next *senseria,* the broker's patent reserved for the official state painter, then held by the aging Giovanni Bellini. After some to-ing and fro-ing, the offer was accepted, and when Giovanni died in 1516, Titian became the new state painter.

This official recognition gave his career a new impetus, and with Giorgione's death and the departure of Sebastiano del Piombo for Rome, the field was open to him. In the same year he began his first great masterpiece, the *Assumption* for the Frari Chruch, completed in 1518 (see page 23). This was followed by the *Pesaro Altarpiece* for the same church (see page 29) and the *Death of St Peter Martyr* (no longer extant, but known to us through engravings). These were innovatory works in which Titian firmly established his own personal style, and they justly brought him widespread fame. The com-

positional and technical brilliance achieved at this period were to be fully developed in the series of visionary masterpieces he painted in his later life.

But it was with portraits that Titian first achieved recognition in other parts of Europe, and he received commissions from the Emporor Charles V, the pope and countless princes, dukes and statesmen — his portraits illustrate generations of the European nobility. His engagements after receiving the coveted *senseria* are a testimony to his ever-growing reputation, and he quickly gained the patronage of the dukes of Ferrara, Mantua and Urbino.

In 1525 he married the woman with whom he had been living for some years, Cecilia, the daughter of a barber in Cadore, thus legitimizing their first two sons. It was to be a sadly brief marriage: Cecilia, already ailing, recovered to bear two further children, only one of whom survived, but she died in 1530. The artist was

GIORGIONE
The Tempest
c 1505-08, Accademia, Venice

Giorgione, whose life was cut short by the plague in 1510, is an artist about whom very little is known. His enigmatic personality is reflected in works such as this, where images were improvised as the mood developed: X-ray photography has revealed that a nude woman originally sat in the left-hand corner where the young man stands. What the painting actually symbolizes can only be a matter for speculation. The landscape and sky seem to echo the figures' strange relationship and, as we try to decipher its enigmatic meaning, we are drawn into the scene as creative participants.

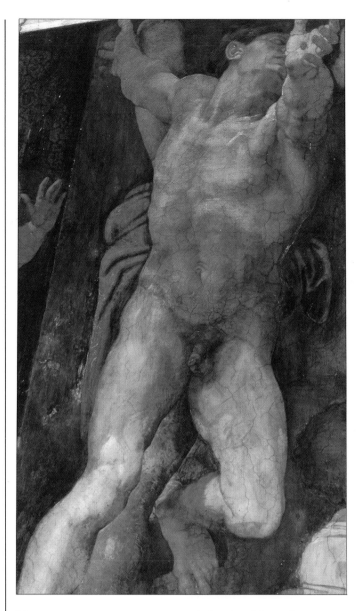

Roman Emperor, ruler of Spain and the Netherlands. Charles conferred a knighthood upon Titian in 1533 and made him court painter, their relationship of mutual respect gradually ripening into a close friendship. This might seem unsurprising today, but in the 16th century, artists were seldom on an equal footing with kings. When Charles decided to abdicate in 1556 it was in front of one of his friend's paintings that he prayed for salvation.

In 1545/6 Titian visited Rome, where he was honored with Roman citizenship, and began a series of portraits

MARTINO ROTA
Engraving after Titian's *The Death of St Peter Martyr* 1530, British Museum, London

This engraving can only give an indication of how impressive this painting, one of Titian's most admired and influential works, must have been. Destroyed by fire in 1867, it was painted for the church of SS Giovanni e Paolo in Venice. The innovatory manner in which the

landscape has been made a dramatic and inseparable part of the narrative set a new standard for altarpieces. The dynamically asymmetrical figure of the saint's companion surging out of the frame shows how Titian has absorbed other influences, drawing inspiration both from Michelangelo's work (left) and the dramatic pathos of classical sculptures such as the *Laocoön* (see page 31).

MICHELANGELO
The Punishment of Haman 1508-12, Sistine Chapel, Vatican, Rome

Michelangelo's masterful ability to position figures in the most complicated of poses is seen here, as the figure is twisted on its axis to create a

vital sense of dynamic energy. His profound understanding of human anatomy and his ability to manipulate figures for dramatic effect were to be an inspiration to Titian, although the latter added a quality of asymmetrical, often informal, design that was very much his own.

devastated by the loss, was unable to work for a time, and moved away from their home, with its unhappy associations, to the district of Birri Grande. He remained devoted to his daughter Lavinia, and painted her several times, but he outlived her also — she died in childbirth in 1560.

Painter of kings and princes
In 1532 Titian met the man who was to become the most prestigious of all his patrons, Charles V, Holy

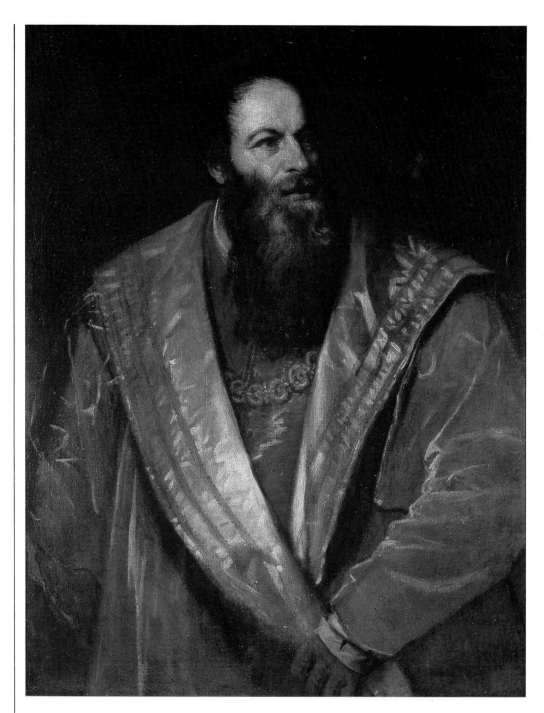

of Pope Paul III and his family, and in 1556 he was elected to the Florentine Academy — truly an international celebrity courted by the rich and powerful of Europe But in spite of his fame and the esteem in which he was held, he was constantly reduced to haggling about money while procrastinating over the completion and delivery of works — the protracted communications between him and his patrons make for fascinating and amusing reading. The Duke of Ferrara, however, was not amused. "We thought that Titian would some day finish our picture — but he seems to take no account of us whatsoever . . . he must finish it under all circumstances or incur our greatest displeasure." The same patron was to be kept waiting for three years before being able to enjoy his *Bacchus and Ariadne* (see page 31).

Titian continued to paint until the last, although he withdrew from public life, having outlived most of his friends. He secured the future for his son Orazio, also a painter, by arranging for the transfer to him of the *senseria* and pension. In the late 1580s the elderly master offered to paint a *Pietà* for the Frari Church in return for a burial place in the chapel there, but he died in August 1576 before he could finish the painting (see page 59) The Guild of Venetian Painters were unable to give him the magnificent funeral they had planned because of the plague that was once again ravaging the city, but the artist was buried, as he wished, in the Frari chapel, the scene of his first great artistic triumph.

TITIAN'S PAINTING METHODS

A comparison of this detail from *Pesaro Altarpiece* (begun in 1519) with the one on the right shows the difference in style and treatment between Titian's early and late works.

By 1553, when the *Danaë* was begun, the brushwork had become looser, freer and more expressive.

In the foreground foliage of *Death of Actaeon* form is suggested by directional strokes of a paint-laden brush.

Titian was an innovator, both in composition and in technique, and his impact on the subsequent history of painting has been enormous. His later works, at one time regarded as the careless and slapdash efforts of an artist past his prime, are now particularly admired for their bold brushwork and freedom of handling; like many artists he found the means to express his personal vision most fully in his maturity. The contemporary art historian Vasari, who visited Venice in 1566, was struck by the contrast between the careful, meticulous painting of Titian's early works and the vigorous brushwork of the later ones, which were best seen from a distance for maximum effect.

Instead of beginning with a detailed tonal underdrawing, which was the usual practice, we know from X-radiographs that Titian worked his compositions directly in paint, integrating the drawing and painting processes. One of his pupils, Palma Giovane, noted that "he laid in his pictures with a mass of color, which served as the groundwork for what he wanted to express . . . With the same brush dipped in red, black or yellow he worked up the light parts, and in four strokes he could create a remarkably fine figure . . ."

Titian used a variety of different weights and weaves of canvas during his career, but in his later works he favored a fairly rough, coursegrained surface, which gave him an opportunity to exploit the texture to create broken-color effects. The first stage in the preparation of the canvas was the stitching together of two or more widths of fabric, which was usually about a meter wide. It was then stretched and sized, and finally a gesso ground was laid. This, made from gypsum and animal-skin glue, was applied thinly and smoothly so that it filled the gaps between the fibers while retaining the texture.

Titian's achievement

The majestic range of Titian's output, encompassing the universal and the particular, the spiritual and the physical, can be grouped into three main areas: portraits, religious works and the *poesie,* mildly erotic paintings with subjects drawn from mythology. His striking portraits range from the early *Man with a Blue Sleeve* (see page 19) of c 1512 — somewhat Giorgionesque in style although the sitter is presented in a new and more forceful manner — to later works such as *Pope Paul III and his Grandsons* (see page 45), where the sitters' personalities and the interaction between them are caught with dramatic intensity. A comparable deepening of insight can be seen in the religious works. The early compositional innovations of the *Assumption* and the *Pesaro Altarpiece* are developed still further in later works to involve us increasingly in the spiritual experience, and paintings such as the *Entombment* (see page 37), the *Mocking of Christ* and the *Pietà* are profoundly moving. In the *poesie* a similar trend can be seen, with the boisterous sensuality of the early *Bacchus and Ariadne* developing into the sublime works of the 1550s. In paintings such as *Diana and Callisto,* one of the series painted for Philip II of Spain after the abdication of Charles V, or the *Death of Actaeon* (see page 53), a deeply personal awareness of humanity's suffering is transcended and ennobled through paint.

Perhaps Titian's greatest achievement was his ability to make the physical stuff of paint transcend its humble origins. Looking at one of his paintings we sense the enjoyment with which he dragged, swirled and scumbled his colors across the rough-grained canvas, using its texture to evoke radiant forms and colors that seem to be almost a metamorphosis of life itself. Titian was an innovator in both technique and composition, but none of his innovations was made for superficial effect; they were the means of expressing deeply felt emotions and experiences, and for this reason he is sometimes described as the "father of modern painting." His emphasis on the brushstroke was to be a vital factor in the development of European painting, a source of inspiration to many of the great masters, particularly Rembrandt, whose works share the same quality of emotion at one with the medium. In the modern period, Paul Cézanne's declaration that "where color is at its richest, form is at its fullest" gives a fresh insight into the continuing relevance of Titian's work.

Titian, who began his career celebrating in paint the sensual pleasure of life, ended it by achieving a profound vision of the contrasting, and complementary, side of the human experience. His paintings continue to move us with their ability to encompass the gamut of emotions, and redeem tragedy through a celebration of change, radiating a fundamental optimism. He reminds us that art is not a luxury but an essential — like air, it enables us to grow. This must surely have been his conviction when he chose the wording for his motto (or *impressa*): "Art is stronger than Nature."

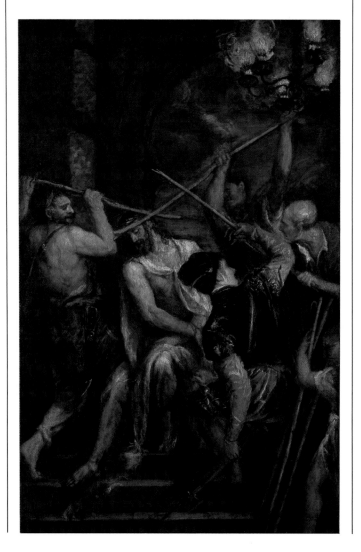

TITIAN
The Mocking of Christ
c 1570-76, Alte Pinakothek, Munich

This work is derived from a composition of the 1540s, now in the Louvre, but painted for the church of Santa Maria delle Grazie in Milan. In the early version, the violence of Christ's torture is treated with a classically heroic pathos drawn from the *Laocoön.* In this version, Christ is attacked from all sides by jabbing diagonals, but his physical torment is understated to emphasize his emotional anguish.

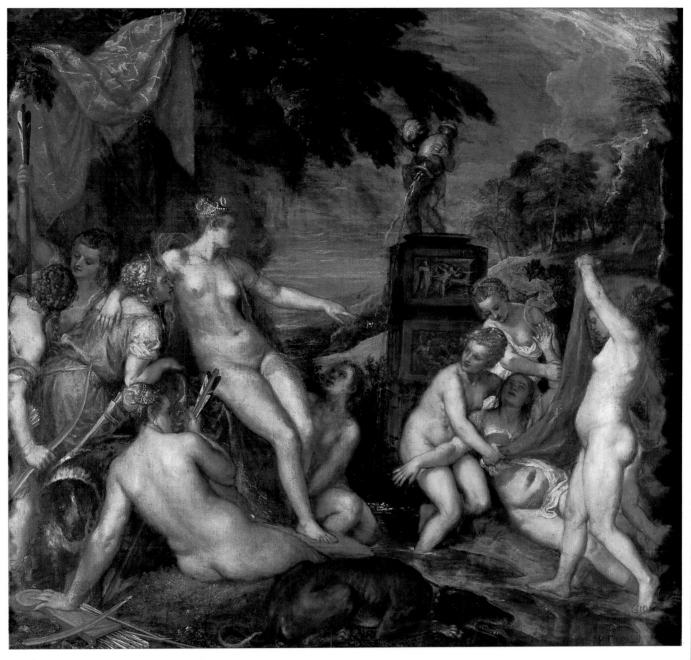

TITIAN
Diana and Callisto
c 1556-59, National Gallery of
Scotland, Edinburgh

This is one of a series of
paintings based on
mythological subjects,
commissioned by Philip II of
Spain. The nymph Callisto,
after being made pregnant by
Jupiter, is banished by the
goddess Diana. Titian uses a
unity of surface texture and
color to suggest a flickering
light, dissolving the figures
into a landscape which seems
to reverberate with Callisto's
sense of loss.

CHRONOLOGY OF TITIAN'S LIFE

c1477-90 Titian born in Pieve di Cadore to Gregorio di Conte Vecellio and Lucia.

c1497 Apprenticed to Zuccato in Venice.

c1500 Enters workshop of Gentile Bellini and then Giovanni Bellini

1508 Assists Giorgione with murals at the Fondaco dei Tedeschi

1510-11 To Padua: paints three frescoes in the Scuola del Santo

c1512 Paints *Man with a Blue Sleeve.*

1513 Invited to join Papal Court in Rome but declines Offers to replace 14th-century fresco in Sala del Maggior Consiglio, Venice, in return for next vacant *senseria* (broker's patent)

1514 March: Offer rejected (after complaints from other painters) but, by November, regains commission

1516 At the court of Ferrara. Giovanni Bellini dies.

1517 Awarded *senseria.*

1516-18 Paints *The Assumption.*

1519 Given contract for *Pesaro Altarpiece.*

1520-23 Paints *Bacchus and Ariadn*

1523 Contact with Gonzaga Cou Mantua.

1525 Marries Cecilia: three childre Pomponio, Orazio, and Lavini

c1525-32 Paints *The Entombment.*

1526 Completes *Pesaro Altarpiece.*

1530 Attends coronation of Charles V in Bologna. Paints copy of portrait of Charles by Seisenegger. August 5: Cecilia dies.

1531 Moves to Birri Grande.

Man with a Blue Sleeve

The Entombment

The Death of Actaeon

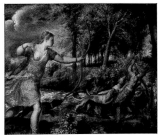

The Venus of Urbino

1532 Beginning of relationship with the Duke of Urbino.

1533 Knighted by Emperor Charles V.

1538 Paints *Venus of Urbino.* Sala del Maggior Consiglio commission eventually finished, but *senseria* taken away because of his procrastination.

1539 *Senseria* restored.

1543 In Ferrara for meeting between Charles V and Pope Paul III.

1545-6 In Rome. Meets Michelangelo; sees his and Raphael's works. Receives honorary Roman citizenship. Paints *Pope Paul III and his Grandsons.*

1548 Meets Philip II in Milan.

c1550 In Germany working on first portrait of Philip II.

1553-4 Paints *Danaë* (late version, Prado).

1555 Daughter Lavinia marries.

1556-9 Paints *Diana and Callisto.*

c1562 Paints *Death of Actaeon.*

1565 To Pieve di Cadore to supervise the execution of his designs in the local church.

1566 Granted copyright to engravings from his work. Elected to membership of Florentine Academy.

1569 Has *senseria* transferred to his son Orazio.

1571 Writes a letter to Philip II from whom he received a state pension. The king transfers the pension to Orazio.

1576 August 27: Titian dies. His *Pietà*, unfinished at his death, is completed by Palma Giovane.

THE PAINTINGS

MAN WITH A BLUE SLEEVE

c1512
32×26in/81.3×66cm
Oil on canvas
National Gallery, London

This portrait, once believed to be of the poet Ludovico Ariosto, has also been thought to be of Titian himself, as the letters "TV" are signed on the parapet. We may never be sure of the sitter's identity, but he is certainly a confident and commanding figure, as was Titian, who was sufficiently sure of himself to make an offer for the highly prized *senseria* in 1513 (see page 10).

By the beginning of the 16th century, portraiture, both in the Netherlands and central Italy, had moved towards a greater realism. In the Netherlands the sitter was often shown in a room, sometimes with a glimpse of landscape seen through a window behind the head. A different convention was used in central Italian portraiture, where there was usually little indication of a specific interior. Instead, the wall behind the sitter, a surface parallel to and not far behind the picture plane, was a pictorial device to create shallow space, within which the subject was placed with a platform-like parapet just in front of him. This may perhaps have been a suggestion of a windowsill, but more importantly it created a distance between subject and viewer, thus imparting a sense of formality. In such portraits the subject was usually shown full-face, taken to just above the waist and with the head high up in the composition, forming a triangle secure on the steady base of the body.

Venetian portraiture developed in much the same way as in central Italy, although Giorgione, possibly influenced by Leonardo, brought to the formula his own personal form of sensual but elusive poetry. In this early masterpiece of Titian's there is still a strong Giorgione influence, particularly in the blurred and softened edges seen in some areas, and in the use of the parapet, which gives a dramatic twist to the body (*contrapposto*). But there is also a strength and sureness which is Titian's own, and he uses the traditional device of the parapet to project the forceful, almost intimidating personality of the sitter forward into our space. The marvellously fashioned blue sleeve presses out over the parapet, seemingly beyond the picture plane. Its very texture gives a sense of physical presence in the real world, and creates a little breakthrough in the barrier between him and us. The quilted sleeve and the edge upon which it rests indicate tangible space, yet the overall integrity of the canvas' flat surface is maintained.

An underlying sense of aloof detachment, a removed containment, is echoed in the color scheme and handling of the paint. Although there is a soft warmth in some areas, the dominance of blue creates a cool climate, both pictorially and emotionally. Light, falling upon the pyramidal structure, is used to illuminate and clarify the tones and forms, yet at the same time it blurs definitions, losing some contours in shadow and implying rather than stating the passage of one form or texture to another. The dark cloak, its fur lining rubbing against the satin sleeve, creates a resonant silhouette punctuated by accents of light, the crisp edge of the white border echoing the curve of the hairline to the left of the eye, which in turn echoes the overall shape of the pose. Although the man is turned away from us, with his left eye softly shielded in shadow behind the sharpness of the nose, we feel that in a moment he might turn toward us, or tire and look away. His keen, perceptive gaze creates a psychological dilemma: his eyes invite us to approach across the narrow space — but can we be sure that we would dare to?

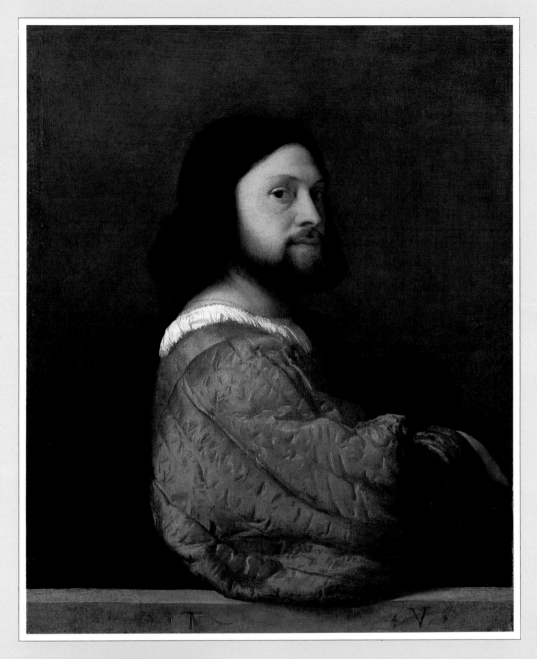

This painting can be seen as being essentially about contrasts — near and distant; hard and soft; cool and warm; intimate and detached. The quilted blue sleeve and the clear edge upon which it rests create a definite tangible space, yet the overall integrity of the flat surface of the canvas is maintained. The sitter's air of aloofness is echoed in the color scheme and the handling of forms; although there is a soft warmth in some areas, the predominant color is blue, creating a cool, restrained climate. The painting established a new canon in portraiture, and Rembrandt admired it so deeply that he based a self-portrait on it (left), using virtually the same composition but with modifications of lighting and color.

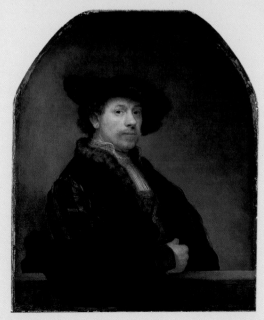

REMBRANDT
Self-portrait
1640, National Gallery,
London

1

2

1 The white of the shirt's edge, applied with short, brisk strokes, blends tonally at the top side with the high key of the flesh, while the white edge below contrasts with the cooler blue. White is carried into this blue to indicate light moulding the direction of form, and this is enhanced by the fine line of golden yellow indicating the chain. This, applied thickly over a series of thin glazes, creates a ridge that physically catches light, adding an extra crispness to the definition.

2 Alternating touches of darkened blue and white are dabbed into the broadly applied blue of the sleeve. Canvas, glimpsed in some places through the blue, gives a violet tint to the material, its warmth linking with the surrounding browns.

3 *Actual size detail* Light flesh hues have been thinly applied to reveal the subtle planes of the bone structure. The delicate pink of the lips adds warmth to the shadow on the sitter's left cheek and to the corner of his right eye, the lids and sockets of which are strongly but delicately defined by single lines of brown. The beard and hairline, applied gently with a soft brush, are in places barely discernible from one another, with brown being worked across the flesh, allowing individual hairs to spread and trail to create an indistinct edge. In contrast to these softly blurred areas, fine lines have been used to define the nostril, creating a sharpness that accentuates the alert intelligence of the face.

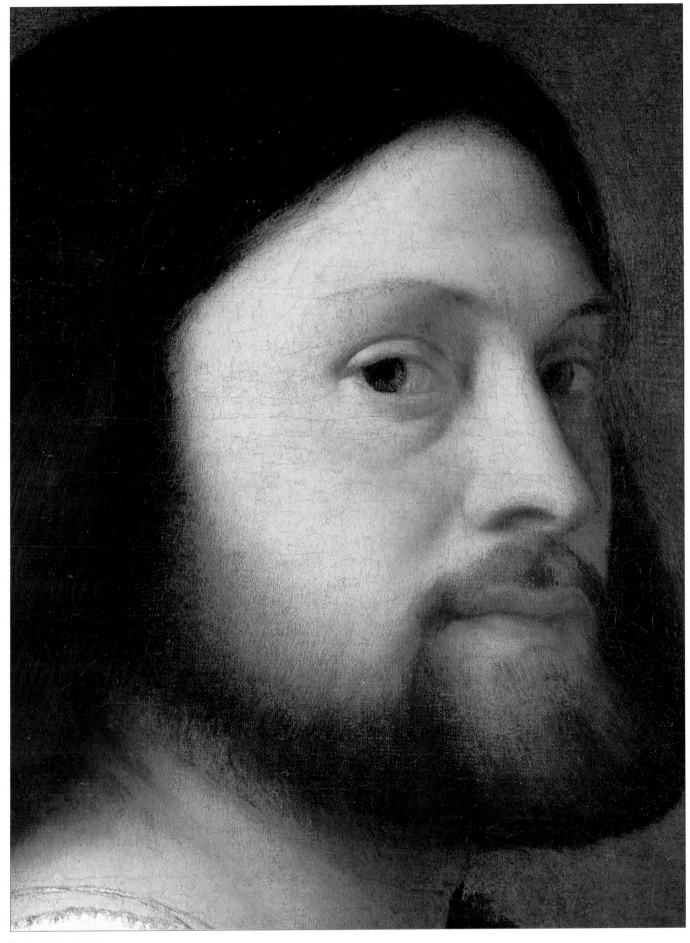

3 Actual size detail

THE ASSUMPTION AND CORONATION

OF THE VIRGIN

1516-18
22ft 7½in×11ft 9¾in/6.90×3.60m
Oil on wood panel
Santa Maria Gloriosa dei Frari, Venice

The Assumption, commissioned by the church of Santa Maria Gloriosa dei Frari in Venice in 1516 and finished in 1518, is the first of several altarpieces by Titian in which he was to establish himself as an innovator both in color and design. The painting set a new standard of monumentality in Venetian painting, rivaling the great works of Raphael and Michelangelo in Rome, and sharing the High Renaissance concern with exploiting the physical setting of the work in order to achieve a unity of the inspirational and the practical. The Frari church, typically of such churches, is organized so that there is a natural progression toward the high altar. Titian's altarpiece, with its heroically scaled figures, was designed to be seen initially from nearly a hundred yards away as one enters the nave's west door, first through high framing columns, and secondly through the arch of a choir screen. The gilded frame of this screen is repeated in the framing of Titian's panel, whilst the arch of this screen is reversed in the painting by the angels, thus visually completing the circle as one approaches. Titian ensures our immediate attention by arranging the design and color to produce an image of certainty, immediacy and uplifting vitality. While the frame's overall shape echoes the church's windows and structure, the color also seems to grow out of its surroundings: reds which link with the brickwork are harmonized and tempered with blue, forming a color relationship that was to become a keynote of Titian's work.

The composition is divided into two geometric shapes linked by the gestures of the figures, who are caught up in a rising dynamic between the earthly and the heavenly. The underlying structure is that of a circle above and a horizontal rectangle below — with the apostles' gestures silhouetted against the blue sky in between these shapes. The yellow of the heavens (echoing the golden domes of Byzantine churches) links with the golden decoration on the church's brickwork. In the lower, earthly, zone the near-hysteria of the apostles is shown by means of contrasting patches of light and dark which confuse their individual forms — jostling arms and legs seem to be emerging from the dark, caught momentarily by accents of light. We are positioned slightly below them, and as we try to make sense out of their confusion our gaze, like theirs, is drawn upwards to the steep pyramid structure of reds formed by the two apostles' robes and the Virgin's dress. This pulls us into the central zone where symmetry is attained by the central vertical of the Virgin as she is drawn up into heaven. Through this vertical runs the spiralling axis of the *contrapposto,* or twisted pose (a device favored by the Florentines). This is augmented by a diagonal of contrasting blue cloth, like an inverted triangle falling off its point, which forks as it rises to our right and is balanced by the Virgin's steadying hands rising to our left, leading us on to a third zone. Here, a soaring Michelangelesque God directs our gaze back to her head at the center of the circle.

The cherubic angels, who make up the bottom half of this circle, are painted with increasingly loose brushwork — so that one moves from more densely applied paint at the center to areas at the edges where touches of yellow paint dissolve into each other — creating a radiance of light on the periphery of our vision. As an angel's foot reaches down into the lower realm, so a yearning hand reaches up from the darkness towards the magnetic pull of this radiance. The frenetic agitation is released by a surging upward motion of boldly orchestrated color harmonies from crimson, rose and vermilion through to the brownish red of God's cloak. This glows back into the golden radiance at the center and is both complemented by and contrasted with the cooler, natural blues.

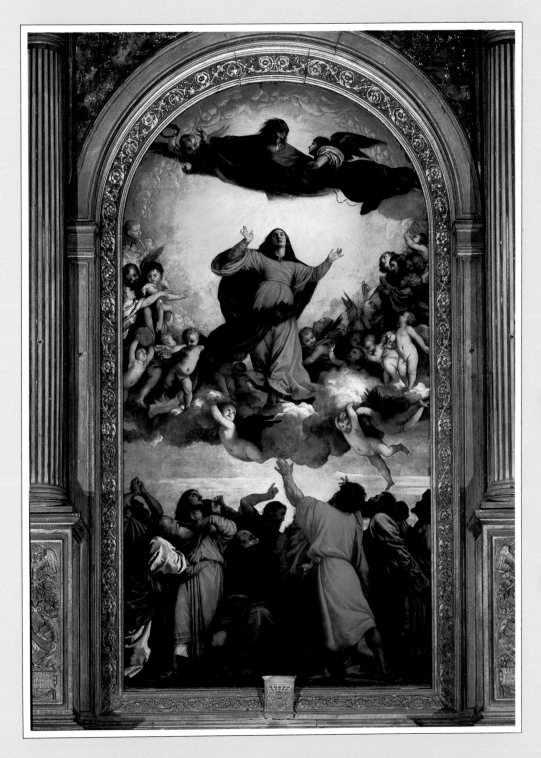

The drama and exuberant vitality of this work shocked the friars of the church, who had been expecting a comforting and reassuring image. It was clear that the artist intended an emotional dramatization of the subject, an innovatory approach at the time. The figures of the apostles, which the prior complained were too prominent, are used by Titian as a pictorial device, the impact of their size forcing the viewer's attention heavenward. All the gestures of the figures, echoing the pointed Gothic windows of the church itself, direct us toward the central drama of the Virgin ascending into heaven, a reminder that the church is dedicated to her glory. The friars were still apprehensive when the painting was unveiled, but the envoy of the Holy Roman Emperor was so impressed that he offered to buy it there and then. Titian's fame was assured.

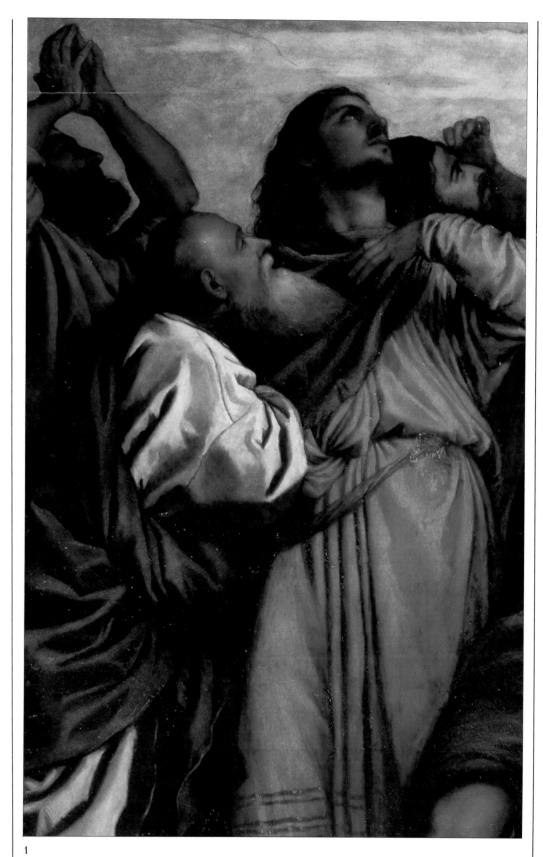

1

2 Strong color and tonal contrasts are created by a firm application of paint, giving abrupt definition to the sharp edges of shapes. Yellow, heightened by white, silhouettes God's dark, stern features, which are indicated with a wiry, linear definition. The forms of his brow, nose and beard are broadly blocked in, as are the angel's sleeve and elbow, so that they jut out into space, and are given warmth by a mixture of reds, browns and yellows used in the surrounding areas.

3 Contrasting sharp and blurred edges create the impression of jostling forms dissolving in light and space. The glowing yellow of the sky is complemented by touches of cool violet which reflect into the faces of the cherubs at the back. Their features are described by very loosely applied strokes, while in the foreground, short stubby strokes are used for the limbs, and the tonal contrasts are strong.

1 The complementaries of red and green create a vital and exciting color contrast while remaining part of the overall mass of the dark silhouette. The reflected radiance of the yellow sky is touched into the red and green shapes, and is then taken through into the dark red-browns which in turn are reflected back up into the hot flesh tones. The heightened definition provided by the clear, crisp brushwork, especially noticeable in the tonal contrasts of the white drapery, is emphasized by the smooth, hard surface of the wooden panel. Less distinct areas of closely related earth colors give a mellow contrast to the brushwork through their soft, smouldering contours.

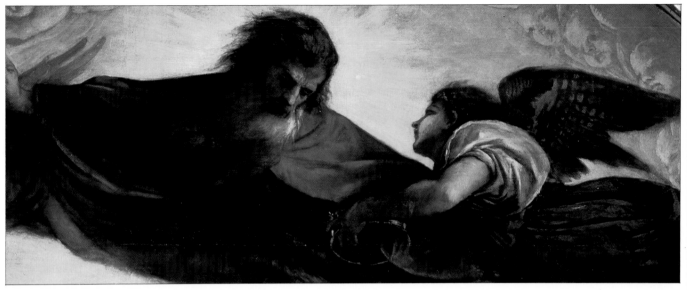

2

3

THE PESARO ALTARPIECE

1519-26

15ft 8in×8ft 10in/4.78×2.68m

Oil on canvas

Santa Maria Gloriosa dei Frari, Venice

The year after the completion of the *Assumption* (see page 23), Titian was commissioned by the Pesaro family to paint another work for the Frari church, but the painting was not completed until seven years later. This altarpiece was to be even more innovatory than the previous work, taking the traditional subject of a *sacra conversazione* ("holy conversation"), but blending the holy with the secular, so that there is as much emphasis given to the donor family as to the Madonna, Child and saints. The donor was Jacopo Pesaro, Bishop of Paphos and commander of the Christian fleet that defeated the Turks in 1502. The church was also his burial place, and we see him kneeling in prayer on the left of the picture. Behind him, a flag bearing the Pesaro emblem and the Borgia coat of arms, alluding to Pope Alexander VI, is carried by St Maurice, the patron saint of the crusaders, who pulls behind him two vanquished prisoners, a Negro and a Turk. The Frari is a Franciscan church, and on the right are the two main saints of the order, St Francis and St Anthony, with some members of Jacopo's family. At the top of the painting is the cross of the Church Triumphant, while above Jacopo, at the tip of the banner, is an olive branch symbolizing its peace. Directly below the cross is St Peter, holding the scriptures, his hand positioned at the crossing of two strong opposing diagonals that introduce a type of dynamic composition quite new in a subject like this.

The painting is situated above one of the side altars in the left aisle, and again Titian has organized his design in relation to its location. As one approaches diagonally from the nave, the painting has the effect of extending the interior space obliquely by means of the asymmetrical arrangement of the forms. The perspective vanishing point is located to the left, outside the picture area, thus drawing the spectator into the drama, and the Madonna and Child, who would previously have been shown in the center, are here placed to the right. A diagonal running from the heads of the Madonna and Child to Jacopo is crossed by another one descending from the olive branch to the kneeling figure in red, and these are stabilized by the two vertical columns — almost certainly derived from those separating the aisles from the nave in the church itself.

In the midst of the drama, Titian soothes us with harmonies of color, creating an atmosphere of warm tenderness, and tempering the violent diagonal movement of the figures with a settling triangle of strong color with the blue and golden yellow of St Peter's robe at its tip. St Peter unites the picture, not only in terms of color and composition, but also in terms of the earthly and the divine. The diagonal arrangement of the Madonna and other figures evokes the spiritual and the heavenly, while the color reminds us of the painting's two-dimensional surface, and hence of the worldly and the particular. In the upper sphere of the Madonna's realm a canopy of cloud hovers, casting its shadow on one of the massive columns that leads us down to the donor's family, who are depicted in various ways to emphasize the temporal realm. The elders are shown in strict profile, as though caught on a coin of the past, while at the far right a young man is seen from a less formal three-quarter view. Just in front of him is the youngest of the family, Giovanni, the only one of the figures to look straight at us. His presence is compelling and immediate, a mirror image of the reality of our own concrete world. He seems to invite us in to join his family in their joyous and respectful homage.

This work, departing radically from the traditional type of composition, marked a turning point in Venetian painting. Instead of placing the Madonna and Child in an obviously dominant position at the center of a secure triangular structure, which had hitherto been the convention, they are here placed obliquely to one side, balanced by the opulence of the donor family. Some years earlier, in 1508, Titian had painted the donor, Jacopo, Bishop of Paphos, being presented to St Peter by Pope Alexander VI. The latter was a member of the powerful Borgia family, and Titian clearly thought it diplomatic to include the Borgia coat of arms above Jacopo's head in this work. There is a new sense of informality in the painting, particularly in the realistic treatment of the younger members of the donor family, that seems to make their experience more personal.

1

1 The light cream of the high-keyed flesh focuses our attention on the Madonna and Child, while the relatively small tonal gradation gives their forms a gentle fullness and harmony. The strongly defined shapes of the Madonna's crisp white veil frame the two heads in a translucent white glazed over blue, and the child's limbs reflect the intense red of her gown through lightly blurred strokes. These gentle touches soften the contours of his form, and provide a contrast with the face of the adoring saint. This is much earthier in both color and application, linked with his more coarsely textured robes.

2 The flesh hues of Jacopo and the standard bearer both reflect and are modeled with the warm golden-yellow of St Peter's robe and the orange-red of the swirling banner. Speckled impasto dabs of reflected yellow are deftly brushed into the banner, creating a lovely flicker of light that animates the gold-embroidered surface. The armour is molded with smooth black glazes, given life and sparkle by sharp, darting slashes and dots of thickly applied white.

2

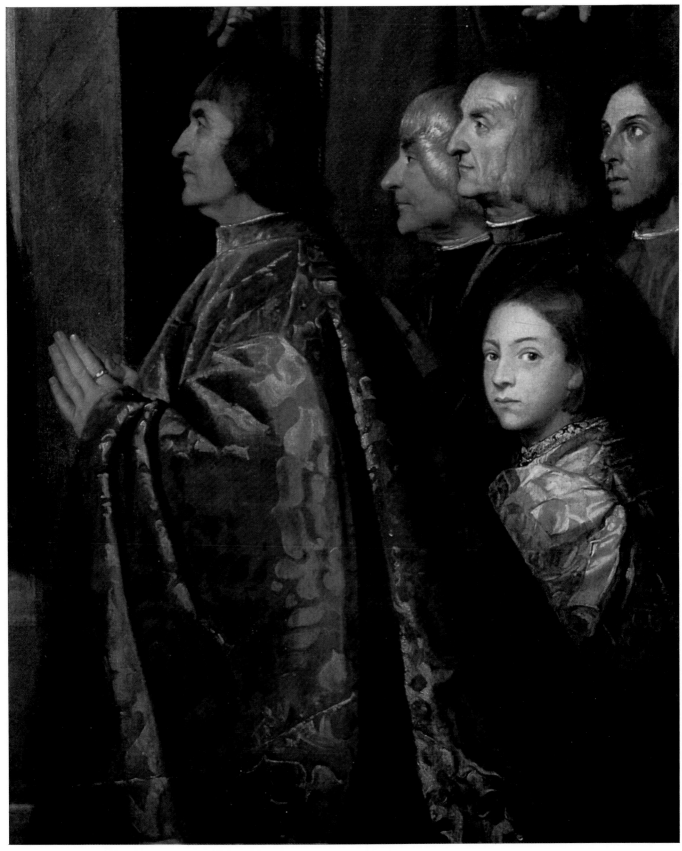

3

3 Over a pyramid of red, fairly loose but coherent touches of yellow-orange and a darker wine-red are applied across the basic glaze to animate the play of light within the triangular shape. Individual facial types are carefully described with fine descriptive brushwork. The young boy's face is the highest in tonal key, and this, combined with the white of his puckered sleeve, makes it shine out from the surrounding warm colors to create a focal highlight.

BACCHUS AND ARIADNE

1520-23
69×75in/175×190cm
Oil on canvas
National Gallery, London

When Alfonso d'Este (husband of the infamous Lucrezia Borgia) became the Duke of Ferrara in 1505, he decided to use his newly acquired fortune to enhance his status by becoming a collector-patron of art. In his castle at Ferrara there was a series of small rooms known as the "alabaster chambers" because the marble in them was of such a lustrous white, and he decided to decorate these with paintings of subjects from the classical world. From the writings of Ovid, Catullus and Philostratus, the Duke chose several episodes involving Bacchus, the god of wine, and asked Raphael to paint a Triumph of Bacchus for the series. Raphael, however, declined and Alfonso then decided that Titian should paint three works for him, of which this picture is one. *Bacchus and Ariadne* is one of the first of Titian's mythological works, which he described as *poesie*, in which mood is conjured, as always by Titian, through color as an expressive entity in itself. Colors are applied as though they were precious stones, creating a rich enamel-like surface where individual hues sing out brilliantly, yet are orchestrated into a unified whole by the tonal arrangement of the composition.

Ariadne awoke on the island of Naxos to find she had been deserted by Theseus — in the painting, a tiny boat on the horizon can be seen disappearing to the left of her shoulder. As she dejectedly wanders the shore, Bacchus sees her and, leaping from his chariot, consoles her and offers her immortality through his love. The painting is full of movement and jostling tension as Bacchus is drawn compulsively towards Ariadne at the extreme left — and we with him. Ariadne is like a magnet, attracting all the figures from Bacchus onwards, but just as her gaze meets his their bodies are drawn into opposing directions, like corkscrews, creating a tension that continually sparks both their expectations and our own. Like Bacchus, we are kept hovering in mid-air; the space between them is electrically charged, crackling over the heads of the big cats whose supple, contained litheness underlines the sensuality of that magnetic attraction. A diagonal running from Ariadne's foot, up to the right through Bacchus' cloak and then up into the trees, is balanced by another from his back foot through to his head. This divides the composition into two interlocking triangles of which Bacchus is the motivating link, drawing together the color orchestration of the painting. His lower limbs are part of the earthy color scheme, uniting the exuberant procession — orange, browns, ochers and greens pulsing in their physical mass — while his cloak, a beautiful clear, scintillating pink, seems to materialize out of the warm blue of the sky. Ariadne's gesture acts as a pivot to the revelers, checking and resolving their pressing weight with her spiraling movement, and is taken up by the bacchante just behind the god himself. This echoing of the poses forms a link between the figures, stabilizing the boisterous throng, as does the tonal interplay of light and dark. The ecstatic writhing of the figures in the earthly lower half, building into a rising crescendo as Bacchus and Ariadne's eyes meet, finds release in the sky, where clouds curve and peak toward the top left corner to culminate in a constellation of stars, while the horizontal cloud above Bacchus meets and pierces the one that echoes Ariadne's vertical twist. The stars not only symbolize Ariadne's future in the heavens, since she is made immortal through Bacchus' love, but also bring completion to the pent-up rhythms of the painting and an end to the touching narrative that it illustrates. As so often in Titian's work, he has resolved conflicting elements on two separate levels through a unified harmony of color and design.

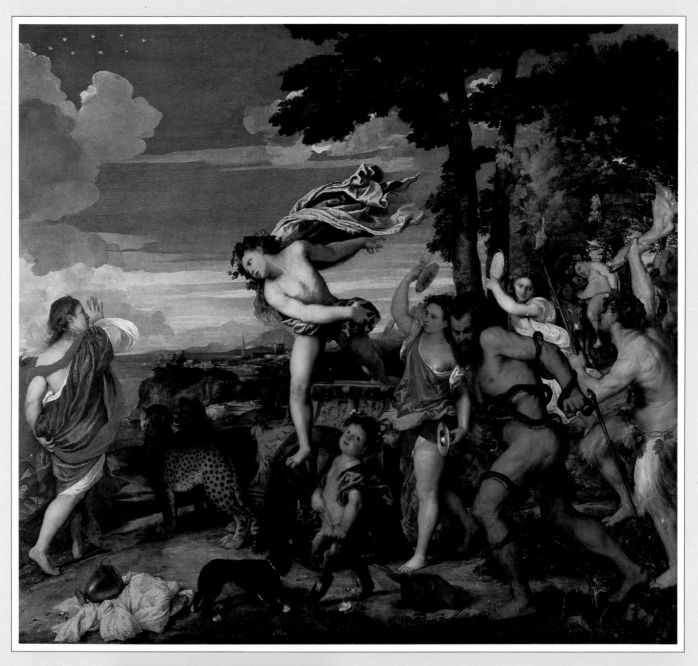

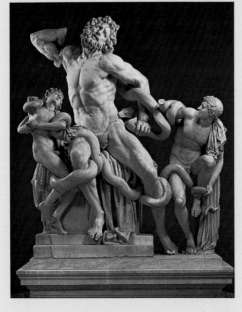

The contrasting blue and red and the billowing movement of Ariadne's clothing increase the drama of her twisted *(contrapposto)* pose, while her dejection as she gazes after her departing lover Theseus is suggested by the way she is placed — isolated on the edge of the composition. But as Bacchus leaps toward her, her body turns back to him, and he simultaneously twists away, his movement leading the eye to the mass of drunken revellers. The bearded figure with the snakes owes much to the late-Hellenistic sculpture *Laocoön,* one of the major classical works rediscovered in the Renaissance, and interestingly, Titian's painting was listed simply as the *Laocoön* in a late 16th-century inventory. Laocoön was a Trojan priest who had disobeyed Apollo by warning the citizens against the Greeks' wooden horse, and the sculpture (left), shows him and his sons struggling against serpents sent as punishment by the god. Its drama and monumentality were an inspiration to generations of painters and sculptors.

Laocoön
2nd century BC
The Vatican, Rome

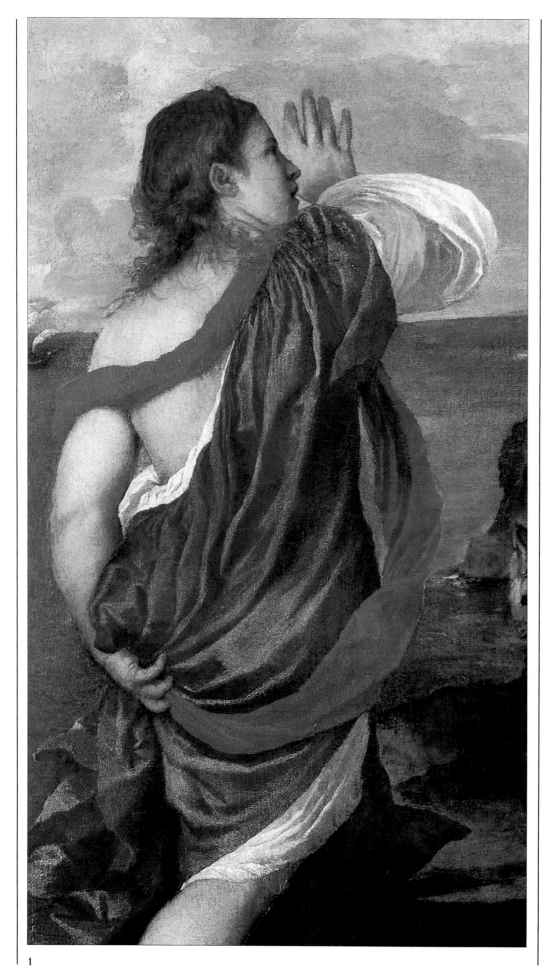

1

1 Ariadne's dress of precious ultramarine, linking with the greenish azurite of the sea, is strongly contrasted with a vibrant, intensely saturated red. This hot red, less varied in its tonal modelling, finds a muted echo in the wavy open strokes of the hair, brushed lightly over both red and blue across her shoulder. The white of the boat's sail, picking up some of the blue of the sea and clouds, seems almost to have been blown onto the canvas in deft strokes that follow the curve of the billowing cloth.

2 Layers of green glazes build up a spatial recession that is deepened by the cool blues that become more and more dominant towards the horizon. Warm light pinpoints forms with broadly touched-in strokes of yellow-green among the deep verdant greens. The distant spire is washed in with transparent paint so that it only partly covers the enamel-like surface of the glazed shapes beneath.

2

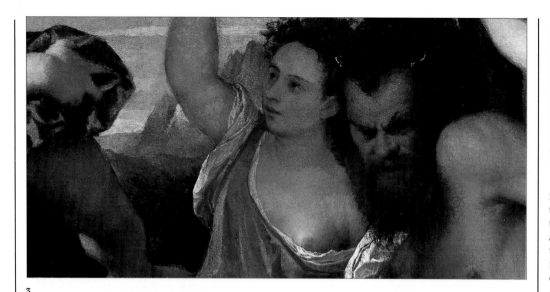

3

3 The clear translucent blue of the glazed sky contrasts with the diffused light that falls across the figures, who are in turn contrasted both in their flesh tones and by the manner of their modeling. For the gentle bacchante in the centre, paint is applied with a smooth, softly gradated touch, while the drunken reveler is described with an appropriate sketchy brusqueness. Bacchus' firmly blocked-in wrist is linked by its high tone to the sky, whilst his swirling robe is boldly described with short, abrupt strokes of sugar pink and deep wine-red that resonate against the cool airy blue.

4 Soft, dappled touches give an impression of drowsiness appropriate to the reveler's drunken state, and the creamy flesh tones are blurred and indistinct. By freely allowing the small brush to spread as it is turned, Titian has given a soft fullness to the plump forms, contrasting with the crisp treatment of the foliage. Loose speckled touches of yellow-green give a lively animation to the vine-leaf headdress.

5 *Actual size detail* The deep translucent glow of the glazed ultramarine is contrasted with the smooth milky-cream of the bacchante's firmly modeled flesh. A sharp edge of white gives a metallic dazzle to the cymbal, which is drawn into with fine black linear detailing. This crisp definition contrasts with the robes, which are freely painted with loose, fluid glazes, a painterly equivalent to the swirling movement.

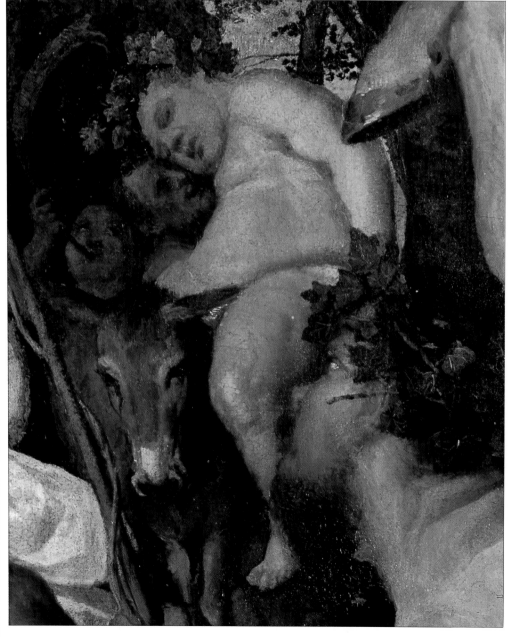

4

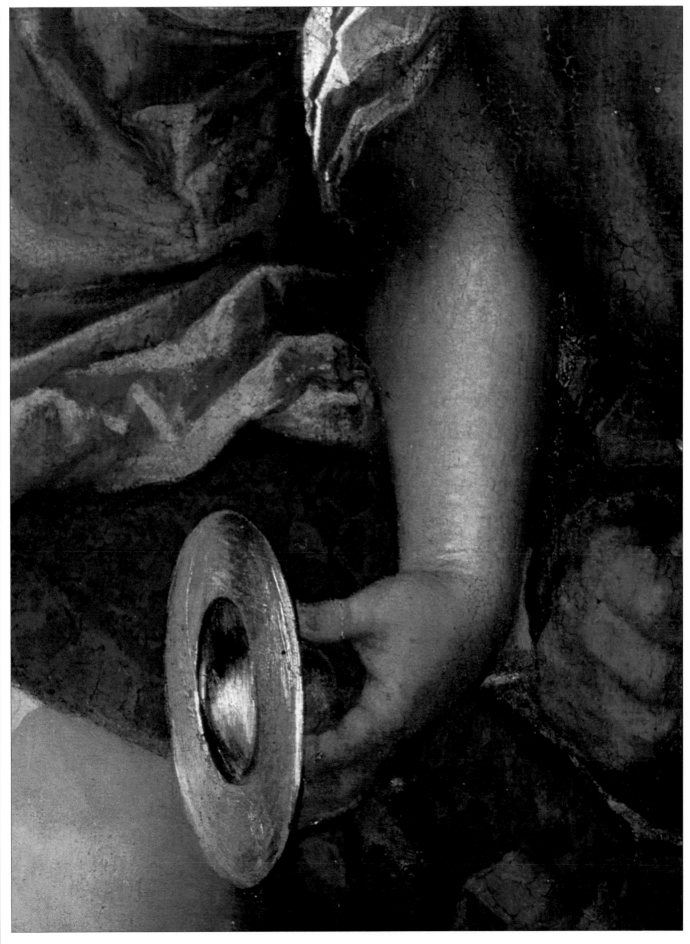

5 *Actual size detail*

THE ENTOMBMENT

c1525-32

58¼×80¾in/148×205cm

Oil on canvas

Louvre, Paris

The dating of this work is somewhat uncertain, but it is generally believed to have been painted between about 1525 and the early 1530s for the Duke of Mantua. It is a deeply moving work, with a profound sense of pathos, rendered in a manner that combines an observed realism of human gesture with the powerful dramatic unity of both form and colour. It is possible that it was painted after the death of Titian's wife in 1530, and was therefore affected by his grief.

The central group of male figures creates an arch that shelters the shadowed Christ, their forms seeming to provide a cave-like hollow suitable for an entombment. This is augmented on one side by a dark, foreboding space and on the other by the responses of the women, the older ones showing a restrained acceptance of death and the young ones a fiery anguish. John, at the center (whose *chiaroscuro* treatment is reminiscent of Giorgione) links the male group to the female as he looks back at the two Marys. His head is inclined to balance the younger Mary's, while the semicircle between their heads echoes the hanging bulk of Christ. The overall grouping maintains the relief qualities of a carved sarcophagus, the shallow space occupied by the figures seeming to confine them, adding to the sense of brooding emotion. Through this space, its smallness underlined by the way the figures are placed up to the edge of the canvas, there is a very gentle rocking motion — like an achingly slow pendulum. This movement, initiated by the bent arm of Mary Magdalene, flows through the arm of the man in green (believed by some to be a self-portrait) through the legs and sagging torso of Christ, to be then turned back towards John by the bent figure of the man on the far right. This somber death-knell is given a poignant counterpoint by a variety of facial expressions and actions: these people are no longer classical "ideals" but touchingly human. In contrast, Christ's face and upper torso are set in deep shadow, as though to protect us from the full impact of the tragedy while allowing him a deep sense of privacy even among those closest to him. Against the grave horizontal swing of these elegiac rhythms, two verticals act as hanging weights, emphasizing the gravitational pull down to the earth. One vertical is implied by the crown of thorns below Christ's knees, indistinct at first, but, once seen, impossible to ignore, and pointing up his humiliation. The second is provided by his hanging arm — limp, drained of life, and trailing pathetically behind as the mourners struggle to move the inert body with dignity.

Around the ashen form, color resonates: the body in its white winding sheet is made yet more tragic by the vivid, living hues that surround it, from the red of John's clothing and the complementary green of Joseph of Arimathea's tunic to Mary's orange dress. The yellow in the dress is taken up in the olive-greens and then cooled by the blues of the Virgin Mary's robes and the sky, where all the colors reappear in the gathering clouds, which echo the mood of desolation. Titian seems deliberately to play off surface textures — of flesh, clothing, foliage and the ground, from which the earth colors seems to emanate — with brilliant sureness and sensitivity of touch. The range of brushwork is remarkable, from a careful clarity, seen especially in areas of tonal contrast, to a bold, free treatment, with broken, loose strokes giving a rich and scintillating shimmer to areas such as the clothing of the bending man on the right, whose long, trailing scarf echoes Christ's hand. Such passages, which evoke an almost sensual response, draw us into the tragedy in a way that no words could — we, like the mourners, move gravely across the scene with heavy steps. In this great work, Titian has used color and design to involve us completely, so that we participate in a moving yet enriching spiritual experience.

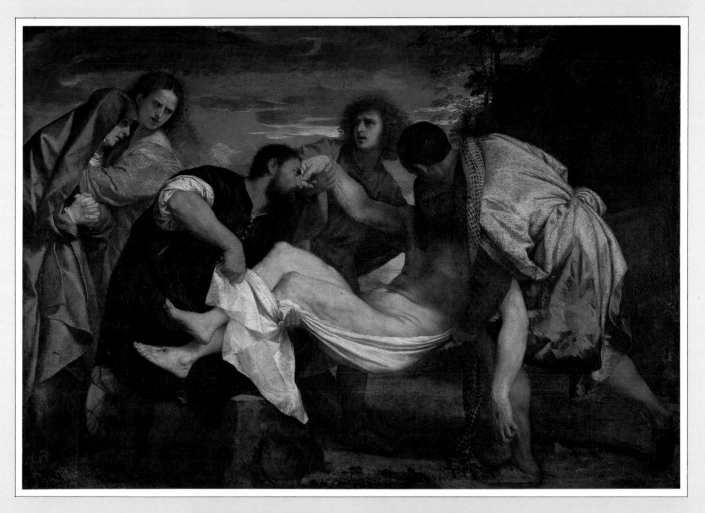

While much of the grouping is enveloped by heavy shadow, we are never in any doubt as to what is happening or what the participants are feeling. The horizontal format seems to stress the mortality of the mourners surrounding the ashen body of Christ, but even though they are in movement, actively gesticulating in their terrible grief, it is the still body that dominates the scene. Titian probably based his design on the death scenes carved on early Christian *sarcophagi* (stone coffins), constructing a frieze-like composition that, although derived from a controlled classical structure, is here made personal and human, with all the figures seen as individuals coping with loss in their own way.

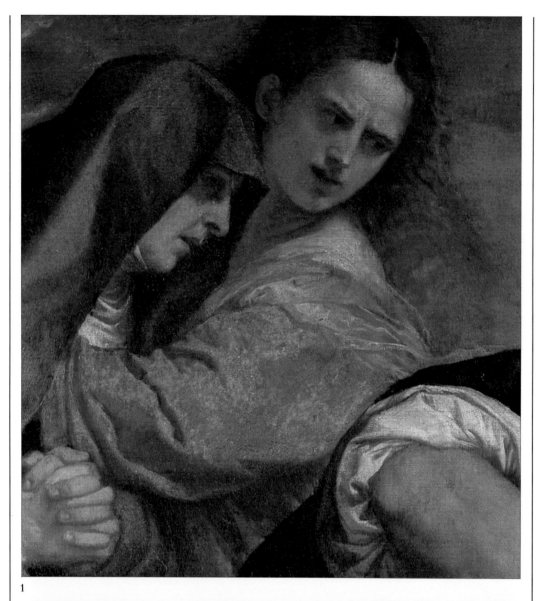

1

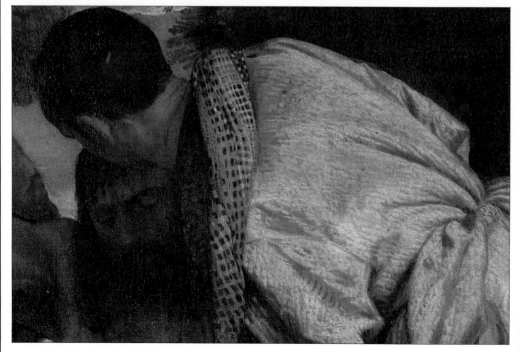

2

1 The blue of the sky, warmed by touches of golden yellow, is also used for the shawl of the elderly Mary, its smooth treatment and muted coolness contrasting with the brown-red of Mary Magdalene's roughly brushed-in hair, flesh and sleeve. The lightness of her diaphanous scarf is suggested by freely brushed, directional strokes and transparent glazes of creamy-white.

2 Loosely cross-hatched strokes of golden-orange and red are applied freely to describe the shimmering fabric of the bending man's garment. Directional strokes of darker red mould the shadow between creases and give some structure to the broad handling, which contrasts with the regularity of the checked scarf. Set against the light mass of the background, Christ's face is enveloped in dark shadow, his features made almost invisible by the subtle tonal variations of the understated dark-brown drawing.

3 *Actual size detail* The high-keyed patch of light flesh tone is softened at its edges, blending into the dark framing silhouette of the hair, which is brushed in gently with strokes following the direction of the curls. The blurred edge of the hair merges into the blue of the sky on the extreme left, but a creamy-white cloud gives accent to its form, with a single curl of reddish brown highlighted against the more substantial layer of white. The soft, wiry facial hair and the dramatic pocket of warm brown shadow that submerge the eyes and mouth, are prevented from completely dissolving the features by the fine modeling of the light side of the face, where delicate, angular touches accent the nose, chin and furrowed brow.

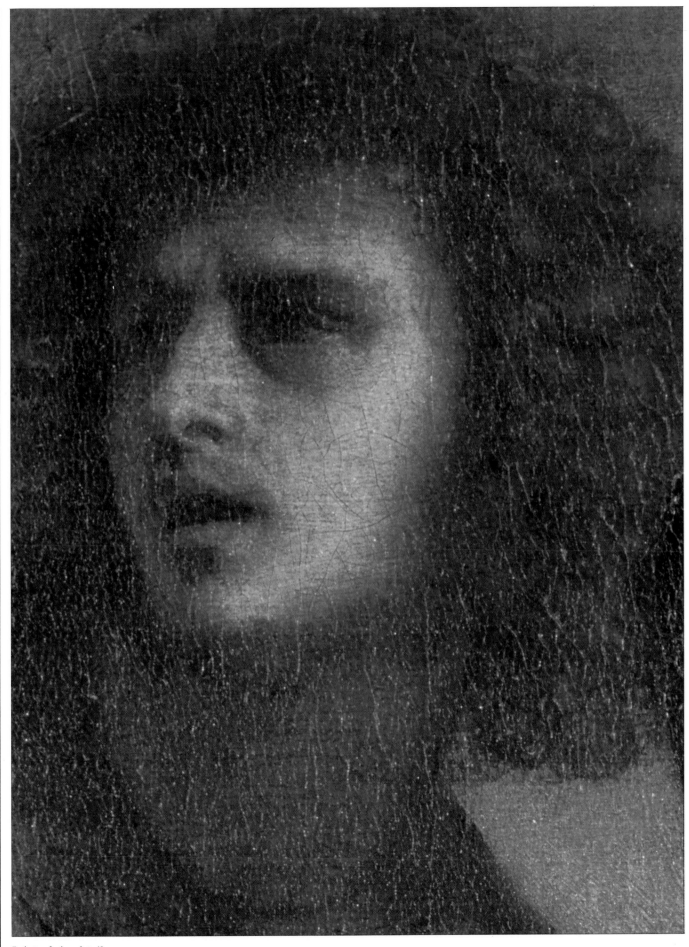

3 *Actual size detail*

THE VENUS OF URBINO

1538
47×65in/119×165cm
Oil on canvas
Uffizi Gallery, Florence

In 1509 Giorgione had painted a *Sleeping Venus* (Dresden) showing the goddess in an idyllic landscape, lying naked with her eyes closed, asleep or deep in reverie. We see her beauty but she does not see us, thus remaining pure and uninvolved. Titian's work is more physical. Although his Venus is shown with the symbolic attributes of a goddess — a posy of roses and a myrtle tree silhouetted in the background — he has moved her into the intimate setting of a domestic interior, where she lies in comfort with open eyes and an air of pampered luxury. We sense her as a mortal, physical woman for whom nudity is not a constant state, as it might be for an idealized goddess in a divine realm. She is enjoying her nakedness, the warm air across her body and the ministrations of her maids, who go about their tasks in the background with professional efficiency. By her feet her little dog, a symbol of devotion and fidelity, snuggles contentedly. At any moment, we feel, it may wake and frisk around, perhaps investigating what the maids are doing before returning to its special, cosseted place in its mistress's world.

Lying back, at one with her setting, Venus's body is modeled — almost caressed — with ochers and pale rose tints, soft yet full and firm against the crisp, ruffled sheets. The smooth openness of the forms is in exquisite contrast with the delicacy of the red pattern below, its angle creating a diagonal that both raises her to acknowledge her audience and sets up a rhythm with the foreground horizontals and the verticals that make up the background. The dark drapery, which not only frames Venus's beauty but also increases the sense of intimacy, combines with the regularly tiled floor and the precise treatment of architectural space to create an ordered structure surrounding her. This measured order sets off her attitude of casual ease, a gently sensual ease that speaks of affection rather than carnality, and is re-flected in her complete lack of self-consciousness. But although comfortable, she is deeply alluring, her flowing curves voluptuous against the stabilizing regularity of the room's right-angles. Titian has made his nude even more alluring by allowing her to retain her jewelry. Her hair, provocatively disarrayed, flows across her shoulder to her wrist, where a single bracelet adds an air of luxury and contrasts with the soft, rounded forms of the arm. The earring provides a focus for our eye, and from it we follow the line of the body down through the excitement of the reds and greens at either side, until finally the vertical of the drapery takes us to her nestling hand. This hand both shields and draws our attention to the most intimate area of her femininity, and the ring on her finger seems to make the gesture even more tantalizing. With tilted head, she gazes almost flirtatiously at us from the corner of eyes which, set beneath heavy lids, smoulder with a sultry langour echoed in the warm, heady Venetian sky behind her.

This kind of painting, providing, as it were, a "private audience" to sit and wonder in close proximity with a beautiful nude woman, was to appear frequently in the history of art, two notable later examples being Goya's *Naked Maja* and Manet's *Olympia*. It undoubtedly has a sexual content, but is more about the detached adoration of beauty than active sexual desire. We can sense this worship of beauty in the way Titian has applied the paint and orchestrated his color harmonies. The strong red and green, golden-brown and whites that set off the flesh tones in the foreground are taken up and repeated with equal intensity throughout the composition. Thus, although we are given the impression of tangible objects in three-dimensional space, the tapestry-like colors are a constant reminder of the flat surface of the canvas, allowing us to become spectators rather than participators in the visual splendor.

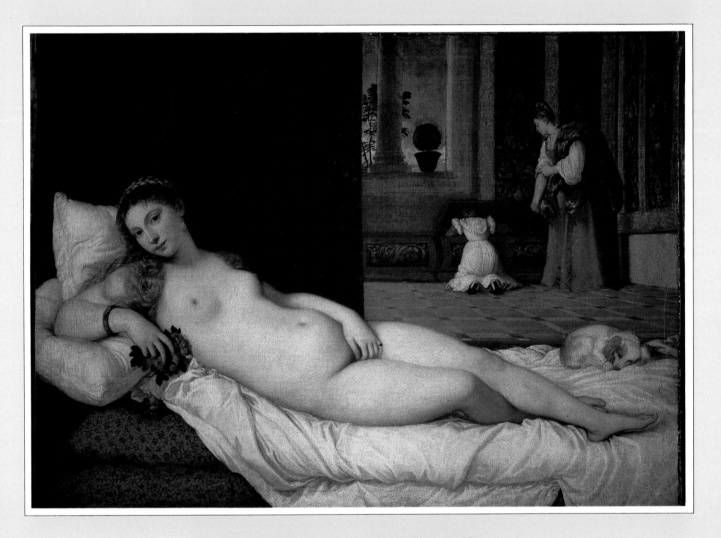

The painting originally belonged to Guidobaldo della Rovere, son and heir of Francesco, Duke of Urbino, at which time it seems to have been referred to simply as *La Donna Nuda* (the naked lady). Guidobaldo had married in 1534, and may possibly have commissioned the work to celebrate the occasion; the *cassone* (marriage chest) in the background seems to support this assumption. Whether it is an intimate celebration of marriage or a depiction of a mistress or courtesan, the painting remains a constant source of delight, and it is tempting to see it as a symbol of the union of a physical and emotional bond — an enchanting allegory of love and marriage.

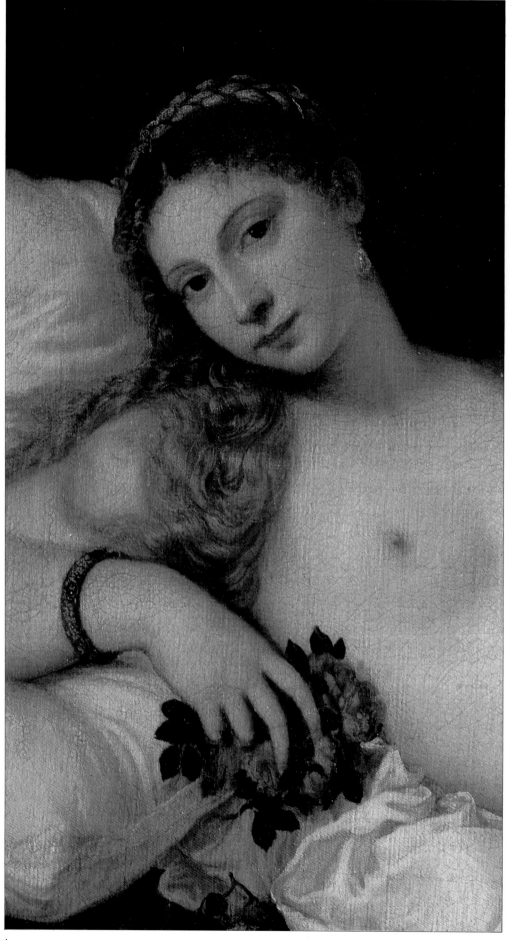

1 The deep red that clearly defines the shape of the lips is lightly brushed across Venus' cheeks and then taken down to her fingers and the posy of flowers. Softened to a delicate rose tint, the red is then used to hint at her nipple, lightly touched into the gently gradated flesh tones of creamy-white ochres and warm siennas. The contours of the ear and head are blended tonally into the hair and pillow, and fine wisps of dark brown paint, applied with curling linear strokes, tease her forehead and then flow in langorous rivulets across her shoulder. Heightened and warmed with golden brown streaks, these cascading waves of paint are contrasted with the undisturbed expanse of the chest, which is lightly molded by barely perceptible brushstrokes. Fine, detailed brushwork is used for eyelids, brows, bracelet and hair braid, with small pointed touches giving emphasis and a physical presence. This is especially noticeable in the treatment of the earring, where a tiny blob of impasted white is delicately dropped onto a silvery-gray glaze.

2 *Actual size detail* Touches of white and ocher, loosely trailed over the strong red to indicate the pattern of the skirt, are flicked up into the material across her shoulder. From there, browns, dark greens, and the cream and white of her flesh and sleeve, are brought down again into the skirt, the serpentine brushstrokes creating a lively and animated surface pattern. Browns and ochers are thinly applied to build up the pattern of the wall behind, while a thicker, shorthand-like notation of white enlivens her hair and the edging of the scarf around her neck.

1

2 *Actual size detail*

POPE PAUL III AND HIS GRANDSONS

1546 (unfinished)
82½×68½in/210×174cm
Oil on canvas
Capodimonte Gallery, Naples

In 1546 Titian was in Rome, having accepted an invitation from Cardinal Alessandro Farnese, and hoping also to receive favors for his son Pomponio, who was a priest. The many letters written by the artist to his hosts asking for the fulfillment of various promises (including the beneficiary of an abbey for Pomponio) were all in vain, nor do the various paintings made of Alessandro and his uncle Pope Paul III appear to have been paid for — judging from Titian's indignant missives. In this work Titian gives us an insight into the atmosphere of underlying tensions and scheming that divided this immensely powerful family — one that was clearly not forthcoming in its generosity. The Pope, a strong advocate for reform of the Church, was also infamous for his nepotism — a word which derives from the papal practice of giving lavish dispensations to illegitimate sons who were referred to as nephews *(nepote)*. The elderly Pope is seated, with Alessandro (who was made a cardinal at the age of fourteen) standing behind him, while from the right Ottavio is approaching with knee bent. Pope Paul is on his guard in their predatory presence, gripping the arm of his chair, knowing as we ourselves can sense, that both are waiting to pounce on any available spoils. A year later Paul's son Pier Luigi was murdered by assassins of Emperor Charles V, and Ottavio did pounce, grasping the opportunity to claim his brother's domains of Parma and Piacenza, with the help of both his father's murderer and of Alessandro. The latter was then called upon to explain the loss of this papal territory to the Pope, and within several days of that grueling audience the Pope himself was dead.

Here Titian uses the full potential of a group portrait combined with the expressive application of paint to catch a moment that seems to be charged with portents of things to come. The painting was never completed, and although we do not know the reason for this, it does not seem surprising.

The pervading red of the color scheme, most intense at the Pope's table, is carried upward to the hovering cardinal before being cooled and accented in the Pope's cape by a creamy white, which is used to balance — and relieve — the reds, browns and russets that dominate the composition. A mixture of these smouldering colors is used to create the murky background, where a large heavy curtain is draped — a curtain that could very easily conceal an ominous intention, perhaps even a skulking grandson. From this dark, oppressive area, Ottavio emerges. From Alessandro's eyes at the top left, an implied diagonal runs down to the bottom right, separating the composition into two halves. The upper section presses claustrophobically forward, its color massing into browns and deep wine-reds, dark in tone save for the two light shapes which pinpoint the presence of the obsequious Ottavio. The strong light against dark contrast of his profile combines with his lowered eyes and stealthily genuflecting knees to give a vivid sense of an insidiously fawning schemer. Caught both compositionally and psychologically between him and the over-pious Alessandro, hand raised in blessing, is the Pope — his suspicious glare directed at Ottavio. He sees through his grandson, but this wily old man needs eyes in the back of his head also, and time is running out — the table clock, a solitary witness on the extreme left of the painting, is ticking away his last days. Titian catches this charged atmosphere with electrifying clarity. With deft touches of broken color over layers of glazes he sets up an uneasy surface tension that reverberates across the composition to produce a work that is both disconcerting and mesmerizing — its unfinished state even adding to our curiosity and apprehension.

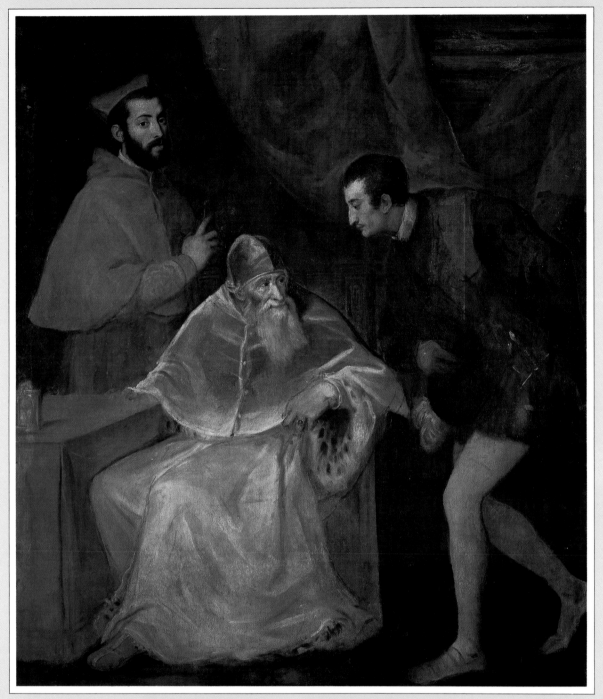

Titian is alleged to have said on one occasion that "a good painter needs only three colors, black, white and red," and it is these three that form the basis of this work. But while limited in color, it is vast in its psychological complexities and prophetic implications — a daringly realistic portrayal of plotting and intrigue. Because the painting is unfinished we can see more clearly how Titian worked, composing directly with a brush instead of beginning with a careful tonal underdrawing. X-rays have revealed that Alessandro, on the left, was originally standing further to the side, but was moved in closer, presumably to press his case more subtly than his brother, who watches him from the other side.

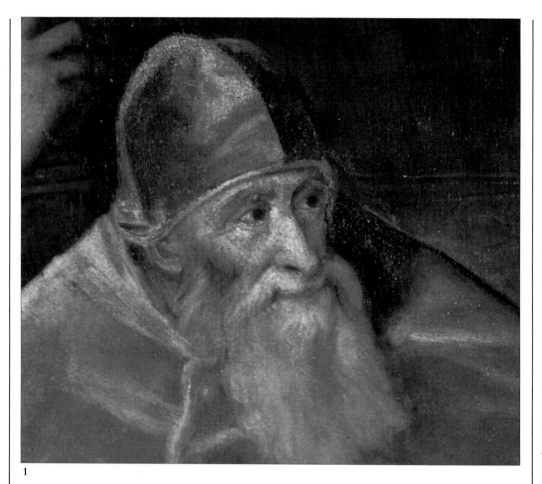

1

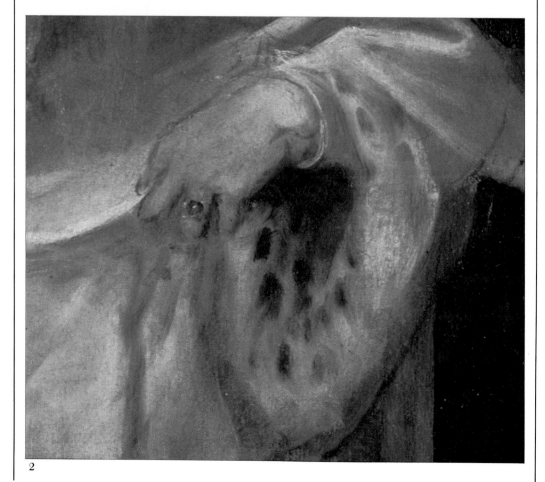

2

1 Wine-red is modified with white, applied with the edge of the brush to give a strong diagonal emphasis to the skull cap and right shoulder. Dark brown lines, finely drawn, clarify the eyebrows, the lower edge of the cap and the left shoulder. Opaque white highlights the wrinkled flesh around the eyes, and is also used for the beard, applied in soft wavy strokes, and on the cape.

2 Because the painting is unfinished, we can see how Titian has worked it up in gradual stages. Sketchy brown-black lines indicate the loosely defined edge of the sleeve and the clawing hand, the redrawing of the wrist being particularly notable for its searching of form. Black is darted into the wet white with dabbing touches of varying strengths, the brush being lifted and trailed to imitate the furry edge of the markings.

3 *Actual size detail* A light flesh hue, thickened for the strong tonal contrast of the forehead and sharp profile, has been brushed firmly over the thin dark brown of the broadly applied ground. Lines taken from that base color are then used to draw into the face, especially noticeable around the neck and chin. Touches of russet-pink from the drapery are reflected into the lips, nostril and ear, while brown-gray defines the ear and hair-line.

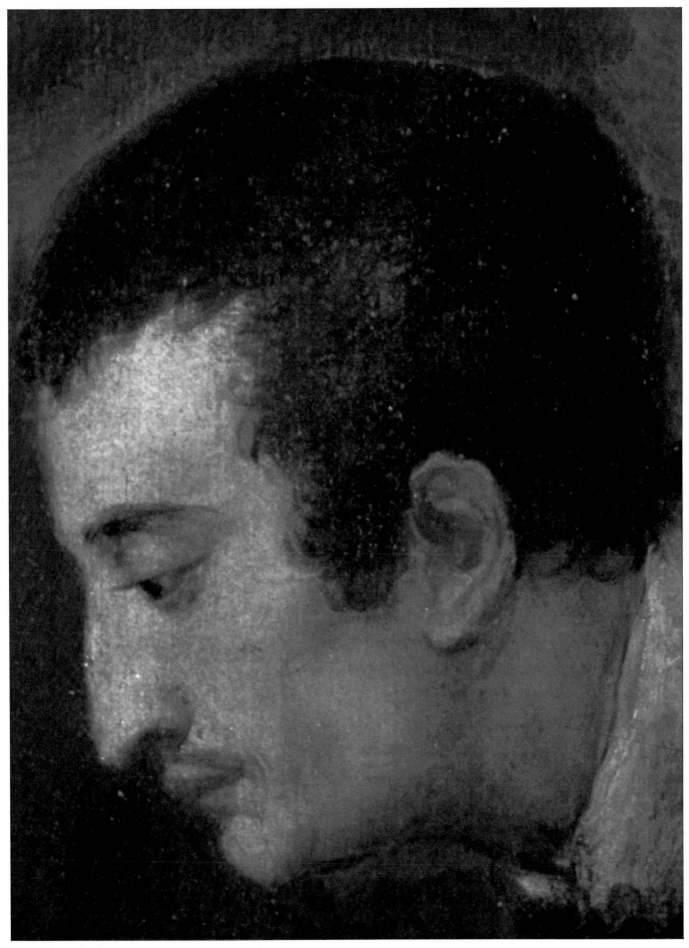

3 *Actual size detail*

DANAË

1553-54
50½×70in/128×178cm
Oil on canvas
Prado, Madrid

One of Titian's most important patrons in later life was Philip II of Spain, son of the Emperor Charles V. Philip, as befitted the Defender of the Catholic Faith, commissioned various religious paintings for the royal palace at Madrid, but at the same time Titian was to paint for him a series of loosely mythological scenes taken from the anthology of stories about the gods and goddesses of classical antiquity compiled by the poet Ovid. These paintings, which Titian called his *poesie,* were distinctly erotic by the standards of the day, and were hung in a private room for Philip's personal delectation. It was this work, the *Danaë,* delivered in 1554, which probably encouraged the king to commission the series (see also page 52), which were to be among Titian's greatest achievements in the twenty or so remaining years of his life.

Danaë, the daughter of the king of Argos, is imprisoned by her father in a bronze tower because an oracle had predicted that a son of hers would kill him. Zeus, transforming himself into a shower of gold, pays court to her, and she bears his son Perseus, who eventually fulfills the prophecy by accidentally killing the king while throwing a discus. The earlier version of the subject (below opposite) was painted in Rome during Titian's stay there, and is in some ways a Venetian challenge to the art of that city, both classical and contemporary, and especially to Michelangelo, whose *Leda and the Swan,* together with his sculptures for the Medici tomb, may well have been a source of both influence and rivalry.

In the earlier painting, the recumbent nude, no longer beguilingly in control as in *the Venus of Urbino* (see page 41), lies back passively, the sprightly animation of the cupid who accompanies her acting as a counterpoint to her inert form. In the later version the cupid of classical myth has been replaced by an aging mortal. The old woman tries to gather the golden coins for herself by holding open her apron, as though in a desperate attempt to clutch the sensual blessings of which passing time has deprived her, thus bringing the story at least partially out of the realm of myth and into the real, mortal world. In both paintings the expectant, abandoned pose of Danaë is set against stabilizing elements: the vertical drapery to the left and the horizontal of the couch. Twisting from the hips — her legs are at one with the picture plane — her torso is pulled round to imply her physical receptiveness, as her head sinks drowsily back into warm shadow. In the later version, however, the limbs are drawn out still further, expressing her aching desire, and the brushwork seems to dissolve the color into a fusion of canvas surface and implied forms that makes the earlier work seem almost sculptural by contrast. From the dramatically stormy sky, a shower of thick dabs of color burst forth, glistening and flashing in the light which also illuminates the flesh of Danaë, delicately colored against the creamy white of the sheets. These broad touches of paint, applied with free brushstrokes that are suggestive of form rather than literally descriptive, create a wonderfully tactile paint surface, the forms seeming to dissolve into one another with a sense of abandon — a visual metaphor for physical sensuality. As in *the Venus of Urbino,* we can sense the three-dimensionality but cannot quite grasp it because the color and brushwork always brings us back to the two-dimensional picture surface. This emphasis on rich surface tensions built up by relating touches of color to one another on the picture plane itself, rather than using colors to give the illusion of space, is more fully developed here. Titian has created an interlocking mesh of touches of color, in which each one resonates against its neighbor, producing an effect of homogeneity that absorbs the voluptuous beauty of the figure into an overall oneness of sensory delight.

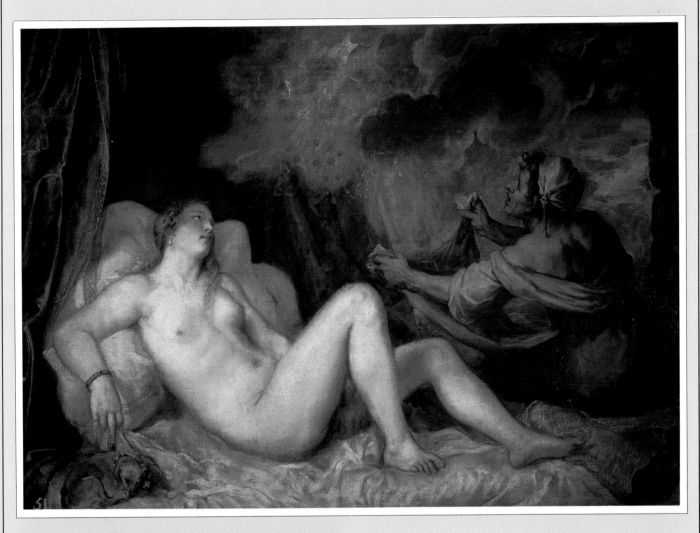

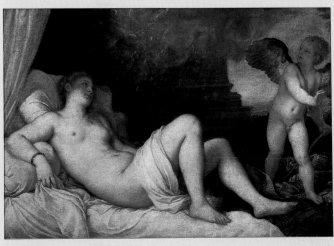

The subject of Danaë was popular with Renaissance painters because it could be used as a symbol for the transforming powers of divine love, and there are versions by both Tintoretto and Correggio. Rembrandt, in the 17th century, also painted the subject, which clearly appeals to painters partly because of the inherent visual possibilities in the shower of gold descending from the heavens. Titian's early *Danaë* (left) was commissioned by Cardinal Alessandro Farnese, and completed eight years before the version painted for Philip II (above). The earlier work shows a tendency that Titian had developed while in Rome, that of restricting his palette to two or three warm colors, thus intensifying the feeling of warm air on soft forms through almost monochromatic harmonies.

TITIAN
Danaë
1545-46, Capodimonte Gallery, Naples

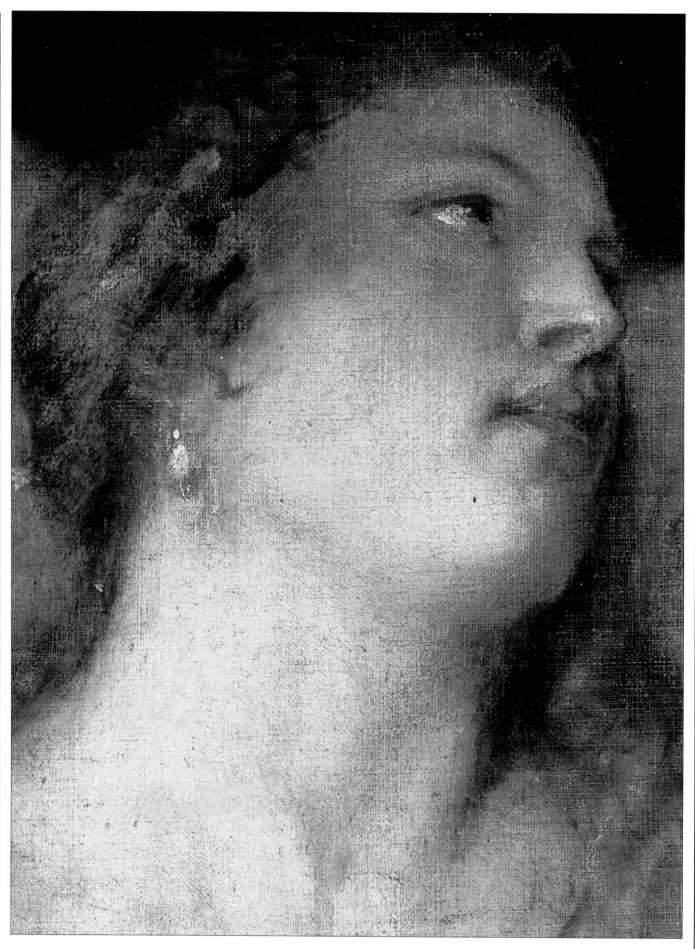

1 *Actual size detail*

1 *Actual size detail* The paint is drily brushed into the grain of the canvas, emphasizing both the forms of the head and the canvas surface. The rose-pink of Danaë's lips and the gray-blues seen in the broad strokes of the pillow's folds are lightly brushed around her cheek, and liquid droplets of white give a sparkle to her eye and earring. Similar touches are used to bring the tip of her nose and jaw out of the warm blue shadow of the pillow.

2 Deep wine-red and warm turquoise are broadly applied for the backdrop, across which drier, creamy-gray strokes, lightly dragged and flicked across the gain, convey a sense of movement. A grayed variant of the turquoise, applied in sinuous, fluid lines, indicates the veins of the clutching hand. From the muscular arm flesh tones are darted over the backdrop in flickering touches, heightened by dabs of white, pink and gray, to give an opulent, material presence to the coins.

3 The lightly trailed and stippled pinks and reds give a broad impression of the pattern of the embroidered bolster, and the tactile quality is emphasized by the way these same colors are brushed lightly into the fingers and then teased into the sheets. Loose white strokes, flurried and scumbled across the grain of the canvas, hint at light catching on the ruffled folds of fabric. The dog is painted boldly, with square-ended brushes following the directions of the forms to conjure the animal from broad fluid strokes of brown and black lightened by white. The white is formed into thick highlights for the collar.

2

3

THE DEATH OF ACTAEON

1559-c1562 (and possibly reworked in the 1570s)
70½×78in/179×198cm
Oil on canvas
National Gallery, London

In 1559 Titian sent a pair of paintings, *Diana and Actaeon* and *Diana and Callisto* (both now in Edinburgh's National Gallery) to Philip II, who had become Titian's principal patron in the 1550s. In the letter from Titian telling of their completion, mention is also made of another work that the had just begun. This is the *Death (or Punishment) of Actaeon,* but it appears that the painting was never sent to Philip, as it is not included by Titian in the list that he made in 1576 of works delivered to the Spanish court.

In this painting and others from the late 1550s we see how Titian has developed the joyous, open exuberance of early mythological works such as *Bacchus and Ariadne* (see page 31) into a smoldering, atmospheric evocation of radiant forms glowing in a flickering light, qualities that typify all the later *poesie.* Titian's name for them was wellchosen — they are truly mood poems in paint.

The belief held in the classical world that painters and poets shared basically the same functions was taken up again during the Renaissance, poets being referred to as articulate painters, and painters as mute poets. This is particularly evident in Venetian painting: Giorgione and Titian both use paint to evoke sensory sensations and mood as a poet would use words, rather than merely illustrating a literary theme. In one of the Greek classics popularized in the age of Humanism, Philostratus the Elder (3rd century BC), discussing some ancient paintings, had asked, "Do you catch something of the fragrance hanging over the garden, or are your senses dull?" Titian, who knew these writings, drew on them, but in a highly expressive and personal manner, in his later *poesie.*

In the story taken from Ovid, Acteon, while out hunting, accidentally chances upon Diana bathing. She takes her revenge by transforming him into a stag, with the result that he is set upon by his own hounds. The pinks, blues and golds of the earlier paintings, such as *Diana and Callisto* (see page 15) are replaced here by a somber monochrome — a tendency first seen during Titian's visit to Rome in 1545. A sense of brooding unease is caught both through the brushwork, which ranges from thin washes and glazing to thick impasto, and the use of what seems to be a very limited palette of only two colors, dark red and brownish green, accented by touches of white, yellow and black. Diana dominates, majestic on the left, her body and limbs drawn out larger than life to emphasize her superhuman power.

Her profile, stormy as the sky that echoes her mood, has a formidable quality of smoldering anger that radiates through every flickering brushstroke, taking us across to the unfortunate Acteon, who disintegrates under a welter of snarling dogs and dissolving paintstrokes. The landscape is shadowy, its details no longer described with botanical clarity, and the clear air of the earlier *Bacchus and Ariadne* has now become dense and "heady," as though nature itself were reverberating with the horrors that are being perpetrated. In *Bacchus and Ariadne* a horseman can be seen rearing in the open, spacious landscape between the two lovers, but here the space between the two protagonists presses claustrophobically forward to the surface of the canvas, and in the ominous and murky wood a wraith-like specter seems to hover fleetingly, to witness Actaeon's death before dissolving back into the undergrowth. In the late *poesie,* the paint is often glowing and radiant, but here it is brooding and clotted, manipulated with brush and often fingers to form clusters that eloquently describe the tensions of the figures and their relationship to one another before fusing into an overall oneness of color and surface texture.

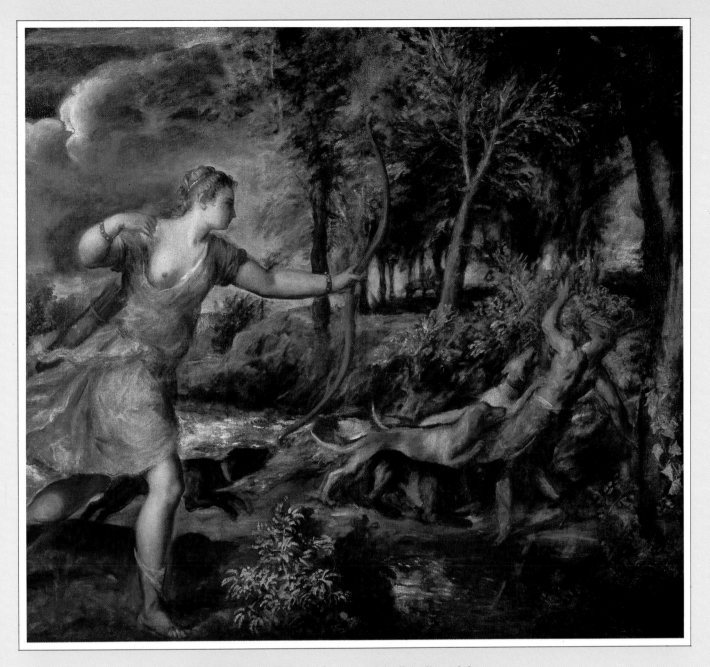

Unfortunately dark tones of the painting have been exaggerated by deterioration. It was once thought that Titian had used a dark oil ground, but recent examination reveals that it was painted on a white gesso priming, which has become translucent through the impregnation of a heavy lining paste, so that the original color of the canvas shows through. In addition to this, fugitive colors and discolored varnish prevents us from now seeing much of the ultramarine used for the sky, the bright greens of the foliage and the vermilion, crimson lake, and various yellows that originally enlivened the surface. But even without this deterioration, the painting would certainly have been darker and more somber than the earlier works, and the application of the paint here more than ever before emphasizes the tactile element of Titian's work — a rich surface of clotted pigment that suggests form rather than literally describing it. The elongation of Diana's body may owe something to the influence of the Mannerist painters, who distorted and exaggerated forms, making much use of tapering limbs and stylish gestures.

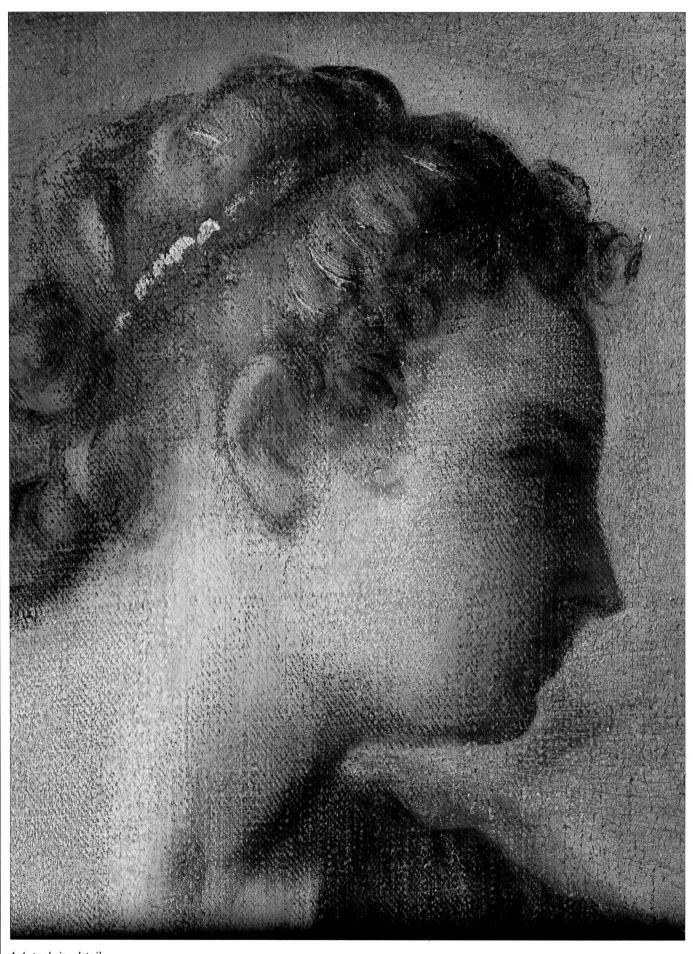

1 *Actual size detail*

1 *Actual size detail* The opaque flesh hues, smoothed over the canvas grain, give form to Diana's face and emphasize her stormy profile by being the most clearly defined area of the painting. The smooth handling of her flesh is deliberately contrasted with the thin glazes used for her clothing. Earth colors, which sketch out the overall composition, give definition to her facial features and to her hair, which is wispily applied over the solid, opaque surface, with touches of white flicked into it for accents.

2 Diana's robe has been loosely built up from thin, roughly applied glazes. Across this translucent surface pinks and whites with a slight greenish tint have been freely applied, with flowing strokes indicating the movement of the floating sash. Fluid brown lines and softly touched-in ochers have been drawn or washed into these broadly massed areas, creating soft, flickering shadows.

3 Loose washes of dark and light color are dragged and scrubbed over the canvas, blurring edges of forms and shadows. Splatters and trickles of fluid, dilute paint sketchily hint at a figure on horseback, appearing to be glimpsed fleetingly before dissolving back into the shadows.

2

3

4 This is a fine example of Titian's later approach to handling paint, when he either applied it freely with a large brush or molded impressions of organic form with his fingers. The bright red used for the dog's collar catches our eye, while strong color and tonal contrasts animate its moving silhouette. Tactile blobs of white and yellow, dabbed rapidly across the rough canvas grain, not only hint at natural forms but communicate the painter's sensual enjoyment of manipulating pigments.

5 Broken, dissolving brushwork is used appropriately to suggest disintegrating form, as Actaeon, now transformed into a stag, is torn apart by his own hounds. Creamy-white, used for the solid physical bulk of the dogs, is slashed onto his waist and up onto his stag's neck. The dark browns and blacks used for the surrounding foliage are here dragged across the canvas grain, hinting at the torso yet also breaking it down. In contrast, lightly slashed curving diagonals of red, pink and orange give substance to the wrap, and the sinewy arm is treated with fine linear definition. On the right, between the arm and the back, is a shape into which are flashed two bold strokes of white which clarify the shadowed side of the torso and prevent the body from merging completely into the ground.

4

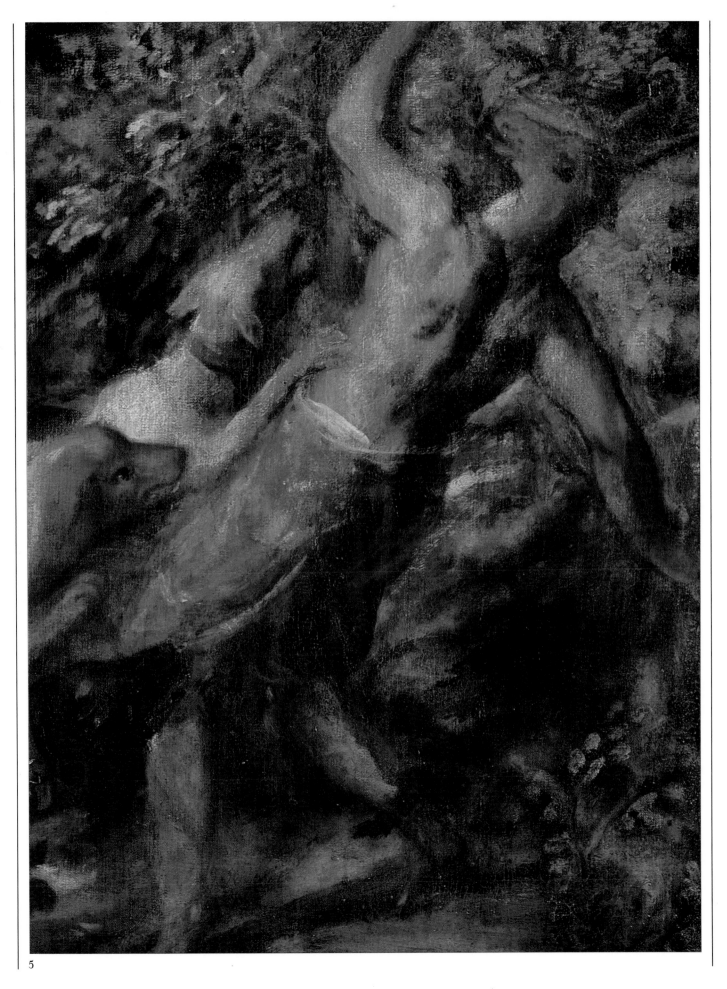

5

PIETÀ

c1570-76 (unfinished)
11ft 6in×12ft 9in/3.50×3.95m
Oil on canvas
Accademia, Venice

When Titian died in 1576, this work was still unfinished. The painting was to have been for his own tomb in the Frari Church, where he had first achieved public acclaim with his *Assumption* (see page 23) sixty years earlier. It is possible his last work may have upset the friars, as the earlier work had done, for when he died it was still in his studio, where it was given some finishing touches by Palma di Giovane. Palma added an inscription — "What Titian left unfinished Palma reverently completed and dedicated to God" — before donating it, not to the Frari, but to the Church of Sant' Angelo.

The *Pietà* has a monumental presence radiating from its flickering light and pigment that raises the mood of pathos to a solemn grandeur. A diagonal from the foot of the aged St Jerome kneeling to the right — probably a self-portrait of Titian — rises dramatically to the despairing head of Mary Magdalene on the left. Her gesture, seeming to break out of the left side of the canvas, is echoed by the glances of the two statues, Moses and the Hellespontine Sybil, who prophesied Christ's death. She carries a cross and wears a crown of thorns, symbolizing Christ's suffering. Our eyes are turned back into this scene of profound mourning by the contrasting diagonal of the angel carrying the candle (the most obvious example of Palma's finishing touches). This balancing diagonal holds the composition in a state of suspended tension, as we are brought back, at the crossing of the diagonals, to Christ, whose dead weight is barely contained by his mourning mother. Christ's pale body, drained of life and blood, and linked with the cold, inert stone of the brickwork and statues, contrasts with the soft color harmonies picked out by the flickering candlelight. The deep rose of St Jerome's tunic is picked up and deepened in Mary's red garments, whilst the blue of her mantle is taken up by Mary Magdalene's green robe, so that our eye is drawn back and forth, by the complementaries of red and green, across the deathly stillness that radiates from the glowing light of the central niche. The stunned silence is broken into with the near-hysterical cry of the Magdalene (derived from a sarcophagus depicting Venus mourning a dead Adonis). Shimmering, loosely applied touches give her form a blurred, quivering sense of motion. Light and dark accentuates her gesture of distraught anguish whilst creating a feeling of imminent disintegration.

St Jerome leans forward to touch Christ's body with a sensitivity that underlines the element of touch that is fundamental to Titian's attitude to paint. We have a first-hand account from Palma Giovane of how Titian painted in his last years. He "laid in his pictures with a mass of color which served as a groundwork for what he wanted to express ... with the same brush dipped in red, black, or yellow, he worked up the light parts, and in four strokes he could create a remarkably fine figure ... then he turned the picture to the wall and left it for months without looking at it until he returned to it and stared critically at it, as if it were a mortal enemy ... if he found something which displeased him he went to work like a surgeon ... the final touches he softened, occasionally modulating the highest lights into half-tones and local colors with his finger; sometimes he used his finger to dab a dark patch in a corner as an accent, or to heighten the surface with a bit of red like a drop of blood. He finished his figures like this and in the last stages he used his fingers more than his brush." The description conjures up a deeply poignant image of the elderly painter moving over the surface of the canvas, his fingers at one with the pigment. "Impressionist" touches catch the transience of time, providing a reminder of mortality in the presence of the eternal.

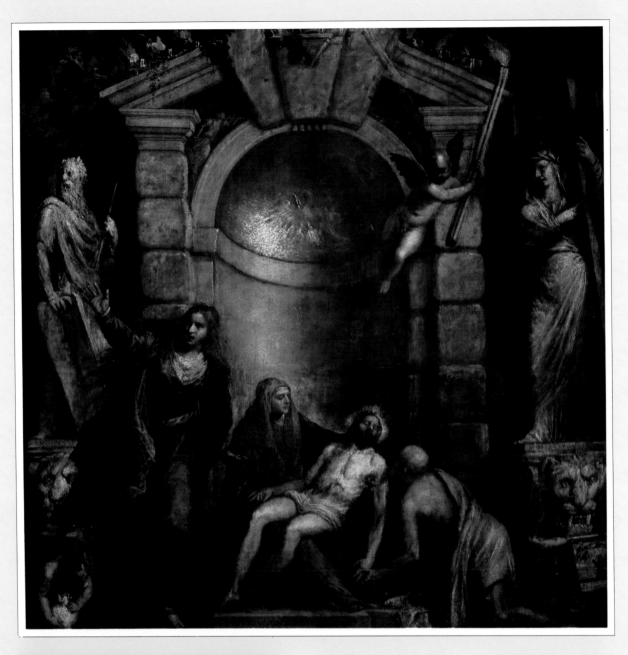

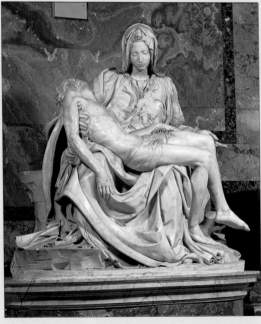

MICHELANGELO
Pietà
1498-99, St Peter's, Rome

Although the almost square format of the canvas at first seems atypical for an altarpiece, the painting does not appear square because the architectural setting for the figures implies the more usual vertical rectangle. Between the two dominant columns, punctuated by the horizontal accents of the rough-hewn blocks, is a half-domed niche evoking both the Byzantine architecture of St Mark's, Venice and the paintings of Giovanni Bellini, whose altarpieces had a profound influence on the religious works of the young Titian. In the shimmering, mosaic-like dome, the artist has depicted a pelican piercing its body to feed its young — a symbol of the compassion of Christ's own death for the salvation of the world. The wedge shape above this dome draws our eye down to the dead Christ and the grieving Mary, their pose clearly echoing Michelangelo's early *Pietà* (left). In the latter work, paradoxes unite to give a heightened reality, the lifesize Christ being supported by a larger-than-lifesize Virgin, who seems also younger than her son.

1

2

1 Strong contrasts of tone are combined with loose, agitated, diagonal slashes of deftly applied impasto, emphasizing the dynamic surge of Mary Magdalene's movement. Dry, crusty paint is used to mold her face, kept in focus by the highlighting of the prominent nose. Her features are warmed by touches of the reddish-brown color of her hair, and this, stretched out in fiery waves (burnt sienna or Venetian red), seems to dissolve yet also to echo the dark silhouette of her shape.

2 Christ's body radiates light. The strong, dryly opaque touches of high-keyed flesh hue are given additional drama and pathos by the ochers, greenish-grays and blacks firmly touched in to form somber shadowś across the chest and ribcage.

3 The creamy-gray and greenish-black of the snarling lion takes on some reflected warmth from St Jerome's orange tunic to the left. Titian has deliberately used a primitive and heavy-handed, almost clumsy, handling for the small panel showing two figures before a tiny image of the *Pietà*. It seems likely that this represents Titian and his son Orazio, depicted on the kind of panel that was popular in his native region. The way it is painted underlines its unpretentious sentiments — a more sensitive painterly dexterity would be most inappropriate for such a humble offering.

3

INDEX

ACKNOWLEDGEMENTS

PHOTOGRAPHIC CREDITS
Alte Pinakothek, Munich 14; British Museum, London 11; Hubert
Josse, Paris 37-39; Kunsthistorisches Museum, Vienna 8 top and
bottom; Louvre, Paris 9; National Gallery, London 19-21, 31-35, 53-57;
National Gallery of Scotland, Edinburgh 15; Prado, Madrid 6, 49-51;
Scala, Florence 7, 10, 12, 23-25, 27-29, 41-43, 45-47, 59-61; Vatican,
Rome 11 left.